MONA LISA TO MARGE

MONA LISA TO MARGE

How the World's Greatest Artworks Entered Popular Culture

Francesca Bonazzoli
Michele Robecchi

Preface by Maurizio Cattelan

Prestel
Munich · London · New York

CONTENTS

6 Image to Power
Preface by Maurizio Cattelan

8 How to Become an Icon
Introduction by Francesca Bonazzoli

22 DISCOBOLUS_____(ca. 480–440 BC)
Myron

26 NIKE OF SAMOTHRACE_____(ca. 295–287 BC)

30 VENUS DE MILO_____(ca. 200 BC)

34 LAOCOÖN AND HIS SONS___(ca. 42–20 BC)
Agesandros, Athanadoros, and Polydoros

38 BIRTH OF VENUS_____(ca. 1484)
Sandro Botticelli

42 LAST SUPPER_____(ca. 1494–98)
Leonardo da Vinci

46 MONA LISA_____(ca. 1503–6)
Leonardo da Vinci

50 DAVID_____(ca. 1504)
Michelangelo Buonarroti

54 CREATION OF ADAM_____(ca. 1511)
Michelangelo Buonarroti

58 SISTINE MADONNA_____(1512–13)
Raphael

62 LAS MENINAS_____(1656)
Diego Velázquez

66 GIRL WITH
A PEARL EARRING_____(ca. 1665)
Johannes Vermeer

70 NAKED MAJA_____(1797–1800)
CLOTHED MAJA_____(1807–8)
Francisco de Goya

74 LIBERTY LEADING
THE PEOPLE_____(1830)
Eugène Delacroix

78 THE GREAT WAVE_____(ca. 1830–32)
Katsushika Hokusai

82 LUNCHEON ON THE GRASS_(1863)
Édouard Manet

86 THE THINKER_____(1880–81)
 Auguste Rodin

90 SUNFLOWERS_____(1888)
 Vincent van Gogh

94 THE SCREAM_____(1893)
 Edvard Munch

98 JANE AVRIL
 JARDIN DE PARIS_____(ca. 1893)
 Henri de Toulouse-Lautrec

102 WATER LILY POND,
 GREEN HARMONY_____(1899)
 Claude Monet

106 THE KISS_____(1907–8)
 Gustav Klimt

110 DANCE_____(1909–10)
 Henri Matisse

114 AMERICAN GOTHIC_____(1930)
 Grant Wood

118 THE PERSISTENCE
 OF MEMORY_____(1931)
 Salvador Dalí

122 GUERNICA_____(1937)
 Pablo Picasso

126 THE BLUE, YELLOW,
 AND RED COMPOSITIONS___(1920–42)
 Piet Mondrian

130 NIGHTHAWKS_____(1942)
 Edward Hopper

134 GOLD MARILYN MONROE___(1962)
 Andy Warhol

138 SON OF MAN_____(1964)
 René Magritte

142 Essential Reading

143 Copyright and Photo Credits

IMAGE
TO POWER

Preface by
Maurizio Cattelan

I have a confession to make: I would like to write this preface using images; words are not for me. To give meaning to what I have in my head, using a string of words, one after another, never satisfies me. What is always missing is the Word that sums up everything. Images, on the other hand, are concise—they can be simultaneously comic and tragic, for example. Everything there is to know is there; one glance is enough to understand.

It's funny, because a few decades ago they said the future would be synesthetic—the supremacy of the eye would be over. Things didn't exactly turn out that way. We spend most of our time looking at a screen and convince ourselves that we know the world through it. Images have a persuasive power that exceeds any word. Whoever wants to hold sway over the masses has always produced and controlled images: once it was popes and kings, today it's advertising agencies. We can't stop looking at images; they appeal to us irresistibly. We end up obsessed with them. Trying to determine why risks stripping them of their magic, diminishing their fascination, destroying their myth. It is a bit like vivisection: interesting, even fundamental, discoveries can be made, but the patient tends to expire during the operation.

Personally, I don't believe in the sacredness of images. Perhaps not all of the artists in this book would be proud to see their work reproduced on mugs and slippers, but this is basically how they achieved immortality. Mass society has adopted these masterpieces and transformed them into advertising campaigns and merchandise. This is how they have become familiar, a public and everyday legacy. It's like taking a phrase overheard in conversation and repeating it in a different context. It's a question of language, a journey in which ongoing exchanges of information enrich every stage. Just as ideas are in continual circulation, images can be as well—they belong simultaneously to everyone and to no one. It's good to consider, as this book does, the innumerable lives of these artworks. Let us not forget that people stopped liking Monet's *Water Lily* paintings precisely when they were given a museum all to themselves; that Botticelli's *Birth of Venus* had to wait for supermodel Claudia Schiffer in order to become truly popular; and that even Leonardo's *Mona Lisa* inspired crowds to line up in front of the Louvre only after it was stolen in 1911. Each had the occasion to become an icon, and each, in turn, has been transformed from icon into myth. And if myths emerge in order to explain a society's culture and customs, I can think of nothing more representative of our time than Michelangelo's *Creation of Adam*, materializing on-screen every time someone turns on a Nokia cell phone.

HOW
TO BECOME
AN ICON

Introduction by
Francesca Bonazzoli

But if we had to name anything which is the life of the sign, we should have to say that it was its use.

......................................

Ludwig Wittgenstein
The Blue Book

How, who, and what has the power to transform a work of art into a secular icon, an image that is universally recognized and even worshipped as an object of pilgrimage and long lines at museums? Why, of all of Auguste Rodin's sculptures, is it *The Thinker* that has become the most famous? How is it that two works by Leonardo da Vinci, the *Last Supper* and *Mona Lisa*, are among the most popular in the world, yet most people who know Caravaggio's name would find it difficult to name just one of his paintings or call them up accurately from memory? And why did Sandro Botticelli's *Birth of Venus*, after being ignored for centuries, unexpectedly become a star?

To put it simply, one might say that there are four factors that are fundamental for a work of art to become famous: what is said, who says it, how it is said, and where it is said.

Yet the answers to these four questions can't tell the full story, for the "mystery of icons," which is anything but schematic and unambiguous, involves history, sociology, and psychology as well as religion.

We might begin with the studies of André Grabar, who traced the origin of the veneration of Christian images to the worship of relics. Beginning in the sixth century, priests began consecrating relics and investing them with divinity through the words of a ritual formula or the sprinkling of holy water or incense. But the image as a simulacrum of divinity, endowed with autonomous power, was a concept that was also present among the ancient Greeks. Aristophanes relates how sculptures by Daedalus—the first artist to depict figures with open eyes, separated legs, and arms distinct from the body— were bound to keep them from running away. The statue of Artemis Orthia, in Sparta, known as Lygodesma ("bound with willow"), was considered extremely dangerous; Pausanias describes how the two men who found it were struck by madness after merely looking the goddess in the eye, leading to the belief that she needed to be constrained and bound. Similarly, when Emperor Constantine built his new city on the Bosporus, he commanded that the statue of Fortune be kept under lock and key so she would not abandon Constantinople. In the Bible, too, everything begins with a statue of man molded from earth and brought to life by the breath of God.

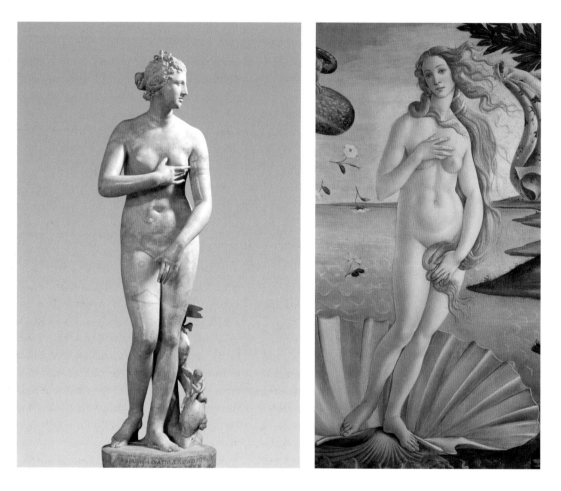

Cleomenes
Medici Venus, first century BC
Greek marble, height 153 cm
Galleria degli Uffizi, Florence

Detail of Sandro Botticelli's
Birth of Venus, ca. 1484

In *The Power of Images*, art historian David Freedberg explains that the phenomenon of consecration demonstrates how all images potentially function before being sanctified. There is an extremely vast repertory from which the priest and the faithful can extrapolate an image to be the object of worship. Once the image is selected, a temple or sanctuary is always constructed around it, which not only protects it from inclement weather but can also become a destination of pilgrimage.

And yet in our contemporary "religion of consumption," as George Ritzer has called it, museums are the temples of art history's icons. People arrive at their doors from all over the world and wait in line to adore Leonardo's *Mona Lisa* or Vincent van Gogh's *Sunflowers*.

Which brings us to another condition that is requisite for the consecration of an artwork as an icon: the place where it is kept. Museums, wrote André Malraux, not only display masterpieces, they also create them. He wondered if the *Mona Lisa* would enjoy the level of fame it does today if it were in a museum in Birmingham. Probably she would, for—as we will see in the section devoted to her in this book—what launched the painting to worldwide fame was the uproar over its theft in 1911 (it had hitherto been known only to the most cultured of audiences, mostly for its prestigious backstory of swapping from one royal collection to another). Yet it is certainly the strategic position of the *Nike of Samothrace* on the Musée du Louvre's staircase that has been fundamental for the fame of this classical sculpture. If the statue had been in Birmingham, to borrow Malraux's paradox, it would likely not have become the pop icon it is today, so famous that it is quoted subliminally in both the crucial scene and the poster for the blockbuster film *Titanic*—Leonardo DiCaprio and Kate Winslet on the prow of the ocean liner, leaning into the wind in triumphant celebration of their love, arms open like wings.

And yet the importance of *where* a work is seen is not a modern peculiarity. For centuries the Vatican's Belvedere Courtyard has conferred a stamp of nobility on the ancient sculpture displayed there, including the *Apollo Belvedere*. Among the thousands of statues that were excavated during the Renaissance, especially in Italy, only some ascended to a special rank, and these were precisely the ones that were privileged with an authoritative site—not just the Belvedere, but also the Tribuna of the Uffizi in Florence, the royal palace of Fontainebleau, or, later, the Musée Napoléon in Paris. Works located in such places became the canon of international taste; copies of them could be found at the palace of Versailles or the Hermitage in Saint Petersburg, in the gardens of English aristocrats, and, at a reduced scale, on tabletops in upper-middle-class homes. As their fame was propagated from exclusive temples of taste, they came to constitute a shared visual panorama throughout Europe. As Montesquieu wrote in *Voyage d'Italie* (1728), "There exist certain statues that connoisseurs have determined to be a norm and example, each in its own way: . . . the *Apollo Belvedere*, the *Farnese Hercules*, the *Laocoön*. And one will never observe these statues sufficiently, for it is based upon them that the moderns have built their system of proportions, and it is they that have virtually given us the arts."

Beyond the site of exhibition, there is another detail that is decisive in the transformation of a work of art into an icon: the identity of its author and the mythography associated with that individual. The crucial nature of this name can be confirmed in any museum when one sees visitors reading the label beside a painting—watch one stop suddenly upon noticing, for example, that the work is by Caravaggio, an artist who has gained a place of primary importance in the modern collective imagination due to his rebellious and profligate life.

Likewise, if new research leads experts to downgrade certain celebrated artworks, such as *The Giant* or

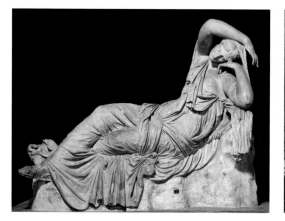

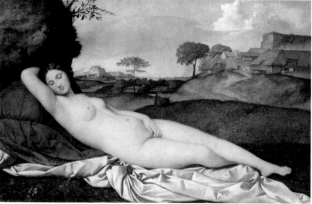

Sleeping Ariadne,
second century BC
Marble, length 235 cm
Museo Pio-Clementino,
Vatican, Rome

Giorgione
Sleeping Venus, ca. 1508–10
Oil on canvas, 109 × 175 cm
Gemäldegalerie Alte Meister,
Staatliche Kunstsammlungen,
Dresden

Francisco de Goya
Naked Maja, 1797–1800
Oil on canvas, 98 × 191 cm
Museo Nacional del Prado, Madrid

Édouard Manet
Olympia, 1863
Oil on canvas, 131 × 190 cm
Musée d'Orsay, Paris

Man with a Golden Helmet, removing the attribution to Francisco de Goya or Rembrandt van Rijn, respectively, those works cease to be objects of veneration. Even a small doubt that they are not by the artist's hand will result in the loss of public affection. In the uncertainty over whether a work is or is not by Leonardo, the "faithful" will remain aloof, keeping an emotional distance, so long as the unanimous opinion of the scientific community (the priest to whom André Grabar refers) fails to officially consecrate the image.

Yet again, even the name of the artist is not, in itself, a sufficient condition for consecration. For example, Andy Warhol's eccentric personality, perennially in the media spotlight, was clearly a determining factor for the success of his images. One cannot say the same for Henri Matisse, who led an uneventfully long, bourgeois life, yet whose *Dance* has left a global legacy.

This brings us to two last factors: what is said and how it is said. Goya's *Naked Maja* is an example of a work that has become an icon because it describes something scandalous, in this case within the context of a millennial series of depictions of the nude Venus—which in Goya's hands was transformed from a classical ideal into a realistic figure, complete with pubic hair and a name identifying the model. We might add to this group Grant Wood's *American Gothic* and Edward Hopper's

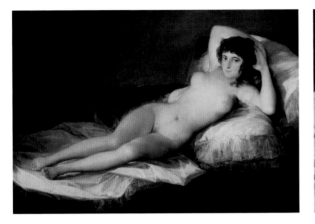
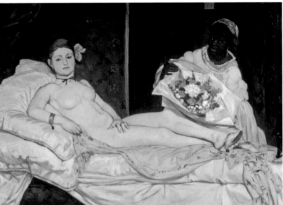

Nighthawks. Both paintings communicate the quint-essence of America, respectively the rural America of the Midwest and the urban America of the East Coast. They are therefore images with precise and very strong messages that succeed in enduring, even leaving the artists in their shadow.

In other words, the recipe for success is complicated; there are some basic ingredients, as we have seen, but the mixture can vary. There is, however, a fundamental moment to which we can trace the success of all of these images: the 1960s, when low-cost reproduction, advertising, travel, and popular access to exhibitions and museums resulted in a massive expansion of the visual panorama, now available to all. Since that time, posters, television, movies, and packaging have brought images into an arena where all are potential objects of veneration—as if in flashback to the sixth century, when prevailing taste consecrated what would henceforth be considered "miraculous images." Indeed, it was during the 1960s that certain icons unexpectedly emerged, others once forgotten (particularly ancient sculptures) reappeared, and still others consolidated their fame. In short, the mass reproducibility of images, far from causing them to lose their aura, as Walter Benjamin predicted in his celebrated essay, in fact enhances their sacred allure and, consequently, the desire for pilgrimage, to see in person

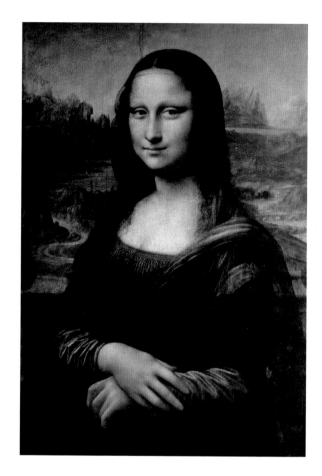

Leonardo da Vinci
Mona Lisa, ca. 1503–6
Oil on poplar panel, 77 × 53 cm
Musée du Louvre, Paris

Jean-Baptiste Camille Corot
Woman with a Pearl, 1842
Oil on canvas, 70 × 55 cm
Musée du Louvre, Paris

Marcel Duchamp
L.H.O.O.Q. after *Mona Lisa*
by Leonardo da Vinci, 1919/1965
Pencil over color lithograph,
30 × 23 cm
Staatliches Museum Schwerin

the originals so often admired in reproductions as the quintessence of beauty. As during the Roman, Renaissance, or Mannerist eras, the copy reverberates and amplifies the fame of the original, arousing a desire to stay as close to it as possible—the same impulse that compels one to touch a holy relic. Whereas the Louvre counted a million visitors each year during the 1960s, by the 1980s its audiences had grown to around three million, arriving at approximately ten million in 2012. The ubiquity of the image, which now exists everywhere—in the pages of newspapers, on television, on candy boxes, on billboards—grants it the power of an increasingly popular and universal fetish, one that can establish itself transversally in cultures the world over.

Given this force of attraction, a work of art must com-pete, to no greater or lesser degree than sacred images, with the reverse: the fury of iconoclasm, the most sensational cases of which were recorded in the twentieth century, with targets ranging from Michelangelo's *Pietà* to Rembrandt's *Night Watch*. The latter has been struck some three times, and on the last occasion was attacked with a knife and defaced with sulfuric acid by a man who maintained that he was acting by divine command. The mentally ill individual who shot at Leonardo's *Virgin and Child with Saint Anne and the Infant Saint John the Baptist* at the National Gallery in London also claimed a hotline to God; he said he acted because the Madonna had looked at him askance. The Frenchman Pierre Guillard, who attempted to attack *The Virgin with Angels* by Rubens, had an identical obsession. "I could

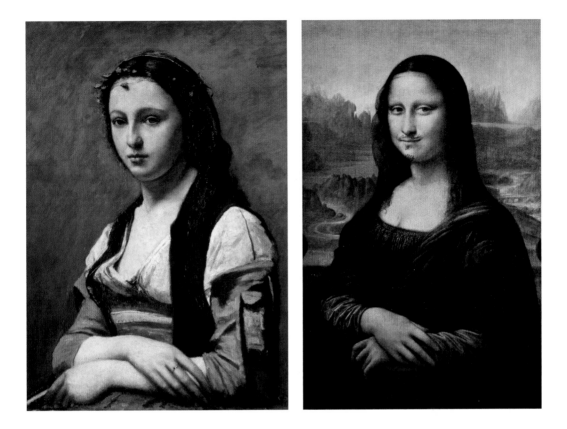

not tolerate the Virgin looking at me in that way, so I decided to kill her," he stated.

If iconoclasm has shifted from the sacred to the profane in museum-temples, the fault lies in large part with publicity. During the Belle Époque, advertising graphics were just emerging; they occupied an area contiguous to that of art. This can be seen, for example, in the extremely elegant Art Nouveau posters designed by Alphonse Mucha for Bisquit Dubouché & C. cognac or by Privat-Livemont for Van Houten cocoa. By the 1920s Earnest Elmo Calkins, the great American advertising executive, could quite rightly assert that the art of advertising, which reached millions of people, was in fact "the poor man's picture gallery."

In this context, certain artistic icons were immediately

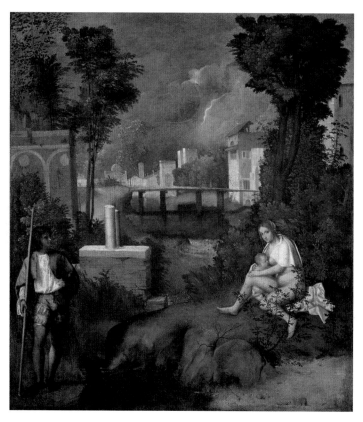

identified as preferential spokespersons. The *Venus de Milo*, for example, was used to sell cereal in the 1910s, aspirin in the 1920s, corsets and pens in the 1930s, speakerphones in the 1960s, and mineral water in the 1980s. But it was during the 1960s, when there was an explosion in consumer goods, that the give and take between advertising and art became truly circular, with art appropriating advertising in turn. Indeed, by this point advertising had become the dominant visual landscape, one that artists could no longer ignore. Andy Warhol clearly understood this when he painted his Brillo boxes, Campbell's Soup cans, and Coca-Cola bottles.

The classics of art history nonetheless continue to be reintroduced and reinvented through modifications of posture and gesture and through semantic interpre-

Giorgione
The Tempest, ca. 1505–8
Oil on canvas, 82 × 73 cm
Gallerie dell'Accademia, Venice

Marcantonio Raimondi
after a design by Raphael
Detail of *The Judgment
of Paris*, ca. 1510–20
Engraving, 29 × 44 cm
The Metropolitan
Museum of Art, New York,
Rogers Fund, 1919

Édouard Manet
Luncheon on the Grass, 1863
Oil on canvas, 208 × 265 cm
Musée d'Orsay, Paris

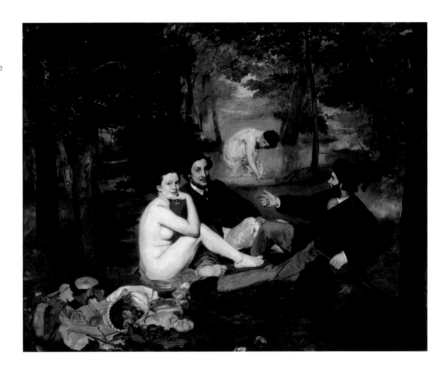

tation. "A classic is a book that has never finished say-ing what it has to say," according to Italo Calvino. The exploitation of the ancient is not an idea that emerged with modernity, but rather a revival of something that dates back to the Renaissance, when the Italians copied, quoted, and modified models of classical sculpture, and in so doing created new works of art in direct dialogue with their ancient sources. And indeed even then, the notoriety of a work could be called truly universal only when it was recognizable, sometimes only through a telling detail quoted and repurposed in new composi-tions. Michelangelo did this, for example, on the ceiling of the Sistine Chapel: in his painting of the Creation, he transformed a torso from *Laocoön and His Sons* into that of God the Father. Similarly, Botticelli's *Birth of Venus*

evokes the *Medici Venus*, but with the face of Simonetta Vespucci, the object of his patron Giuliano de' Medici's love. And even earlier, Romans of the late Republican and Imperial eras had done the same, copying Greek sculpture.

This attitude of (vertical) competition with the au-thority of the model is typical of Western art; Asian art prefers the (circular) repetition of the iconographic canon, without modification. And so in Western art icons often emerge precisely because of confrontation with the authority of the model. Yet because of this, the competition must be fearless, embracing parody, des-ecration, irony, manipulation, or publicity. It is this con-fident and unprejudiced stance that allows the work to stay alive over the centuries. Otherwise the work will fail

to enter the popular imagination and is doomed to remain a "museum piece," quite different from the fetish to which one experiences emotional proximity. Henri Focillon called this the "life of forms": an incessant movement of the image, so that "form, guided by the play and interplay of metamorphoses," might "go forever forward, by its own necessity, toward its own liberty."

In Western culture these two different attitudes can coexist: the work can be transformed into an icon both through its consecration and through its demystification. Transforming an image, even with derision, serves to affirm the power of the symbol. Consider, for example, an engraving, attributed to Titian, that caricatures *Laocoön*, replacing the Trojan priest and his sons with monkeys—a cruel joke on artists' fever for imitating ancient sculpture. This perception of the classical world as an open text would also embrace the desecration effected by the early twentieth-century avant-gardes—as, for example, when Marcel Duchamp placed a mustache on the *Mona Lisa*. The artwork becomes an icon also because it resists manipulation in the passage from one author to the next, be it an artist, an advertising executive, or a cartoonist.

The power of an image is revealed precisely in the comings and goings of its multiple interpretations: from the hand of God in Michelangelo's *Creation of Adam* to that same hand, transformed by Caravaggio into that of Christ pointing at Saint Matthew, and so on, the same archetypal gesture reappearing, from century to century, until Steven Spielberg used it for *E.T. the Extraterrestrial*.

"Religions have from time to time been clannish, tribal, civic, national, continental. The religion of art arises as the first planetary religion. To recompose what decomposes, it embraces all the gods, all styles, all civilizations," writes Régis Debray.

Citations, errors, misrepresentations, betrayals, updates, effacements: all are necessary passages in the making of an icon. Even in the secular worship of art, every sacred image becomes a creative force.

Thomas Struth
Museo del Prado 8-3, Madrid,
2005
Chromogenic print, 140 × 176 cm

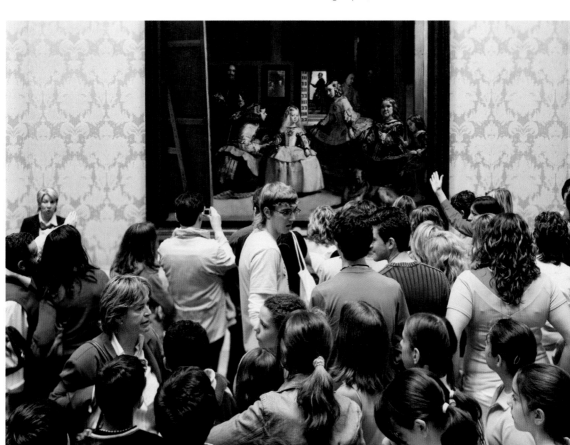

THE
ICONS

DISCOBOLUS
Myron

ca. 480–440 BC Marble, height 155 cm
— Museo Nazionale Romano (Museo delle Terme), Rome

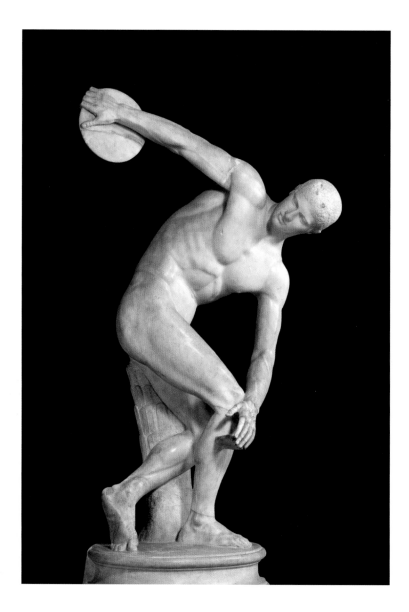

**All one has ever
fancied or seen
in old Greece
or on Thames' side,
of the unspoiled
body of youth.**

.....................................

Walter Pater

Along with the *Venus de Milo*, *Nike of Samothrace*, and *Laocoön and His Sons*, the *Discobolus* by Myron (active ca. 480–440 BC) is one of the few ancient Greek sculptures to have achieved high visibility in modern iconography. But there is a significant difference. Whereas the former works communicate divinity and mythology, the *Discobolus* is a representation of reality, albeit an aestheticized one. Discovered on March 14, 1781, on the lands of the Villa Palombara on the Esquiline Hill, owned by the Massimo family, the statue—a second-century BC Roman copy of Myron's Greek bronze original—was restored by Giuseppe Angelini and placed in the Palazzo Massimo delle Colonne in Rome before being moved to the Palazzo Lancellotti on the Via dei Coronari. A few years later, in 1790, a second Roman copy came to light in Hadrian's Villa and was acquired by the English antiquarian Thomas Jenkins, who in turn sold it to the British Museum in 1805. Two other versions in marble (incomplete) were discovered around the same time, in Castelporziano and on the Via Appia Antica. These multiple discoveries—in conjunction with admiring ancient descriptions of the lost bronze original by Lucian

of Samosata and Quintilian, as well as the 1806 publication in Italian of a collection of epistolary writings on the *Discobolus* by G. B. Visconti and Filippo Waquier de la Barthe, edited by Francesco Cancellieri—triggered a chain reaction that rapidly resulted in the work's increased fame. Ten years later the statue was so well known that it was parodied in one of the athletic putto figures painted in the room dedicated to Romulus at the Palazzo Altieri in Rome. Various European sovereigns expressed a desire to acquire the *Discobolus*, from Ludwig I of Bavaria, who in 1815 designed a room of the Glyptothek specifically for the installation of the sculpture in Munich, to Napoléon, who requested the statue for the Musée Napoléon in Paris.

It was, however, a second wave of popularity that definitively consecrated the *Discobolus*. This occurred around 1896, when Baron Pierre de Coubertin, inspired to bring together nations in the spirit of competition and mutual respect, began expanding the Olympic Games on an international scale. Discus throwing, widespread in antiquity, was one of the sports chosen to perpetuate the tradition of the Olympics, and no image could

Walter Herz
London Olympic Games, 1948
Color lithograph, 76 × 51 cm
Private collection

Print ad for Reebok Classic
Shoes created by the Bartle
Bogle Hegarty advertising
agency, 2000

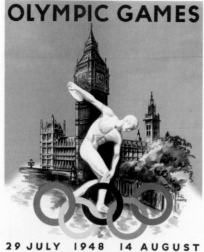

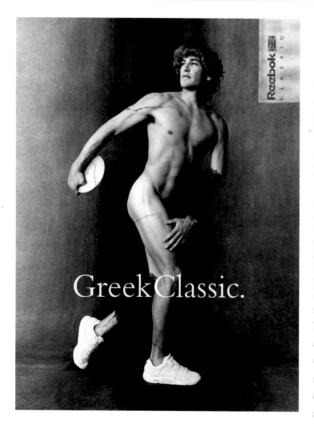

better serve as a bridge between the two eras than the *Discobolus*, an elegant symbol of anatomical dynamism whose perfection represented contemporary athletes even as it reinforced historical ties. Posters, magazine covers, and stamps for various editions of the Olympics have consequently depicted the *Discobolus*, including Antwerp in 1920, Los Angeles in 1932, London in 1948, and Rome in 1960—just a few of the many instances through which Myron's work helped position the figure of the discus thrower prominently in the sporting imagination.

The 1936 Olympics in Berlin charged the *Discobolus* with even further significance, as the figure's physical beauty became overtly associated with political power. In his television series *The Shock of the New* (1980), Robert Hughes observed that every dictatorial regime in the Western Hemisphere has considered classical art, by virtue of its association with the Roman Empire, an indispensable tool for the affirmation of the concept of superiority. In 1930s Europe, Benito Mussolini's recreation of the splendors of ancient Rome basically exploited what he already had at hand, but for Adolf Hitler, the question was posed in two terms: whether to imitate classical art or take possession of it. And thus, just as Napoléon was ruthless in his efforts to obtain the *Medici Venus* in the late eighteenth century, Hitler focused on the *Discobolus*. In 1936 the Nazi hierarchy commissioned Leni Riefenstahl to shoot *Olympia*, a promotional film on the Berlin games, with handsome athletes re-creating poses inspired by classical statuary amid Greek ruins in Athens. Not satisfied with this piece of fiction, in 1937 Hitler communicated to the Italian government his desire to obtain the *Discobolus*. The authorities objected, but Hitler, in no mood to be discouraged, resumed his efforts the following year. On May 18, 1938, Galeazzo Ciano, Italy's minister of foreign affairs, agreed to the sale of the sculpture for five million lire, over the protests of Giuseppe Bottai, the minister of education. The statue arrived in Germany on June 29 and was put on display in

Sui Jianguo
Discobolus, 2003
Fiberglass and paint,
172 × 60 × 110 cm
Courtesy of Pace Beijing

Cover of the December 1941
issue of the magazine *Strength
and Health*, depicting John
Grimek, one of the world's
greatest bodybuilders, in the
pose of a discus thrower

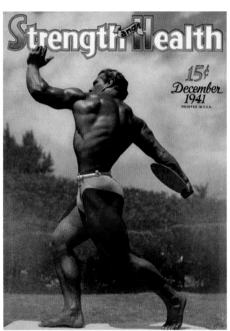

Munich's Glyptothek. It was not returned to Italy until November 16, 1948, and it found a permanent home in Rome's Museo Nazionale Romano on April 2, 1953.

Today the *Discobolus* has returned to represent a model of virility and health, values that various advertising campaigns have not hesitated to exploit and interpret as a celebration of the union between competitiveness and beauty. The perfection of the work's proportions and its impeccable features delineate an idealized figure—one that is engaged in an earthly activity, serving as a force of reconciliation between a divinity and its followers. Yet the secret to its success might actually be somewhat surprising, for in a certain sense it contradicts everything that has been said so far. By portraying the moment of tension as the athlete projects himself toward the attainment of his goal, the *Discobolus* does not technically reveal the air of triumph or pride that has granted it immortality. In a democratic and human way, it personifies the attempt, the moment that anticipates the execution of a gesture, immortalizing the figure's intentions and aspirations—a feeling with which everyone ultimately can identify.

NIKE OF SAMOTHRACE

ca. 295–287 BC Marble, height 200 cm — Musée du Louvre, Paris

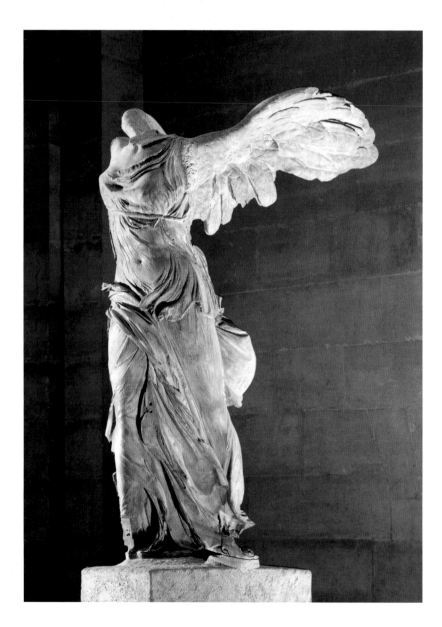

The goddess of Victory
occupies in the Greek religion
a place completely out of proportion
with the almost infinite multiplicity
of its representations.
In this sense, she belongs
to the domain of art
even more than that
of mythology.

André Baudrillart

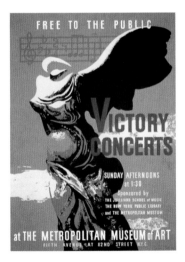

Poster by Byron Browne for a
concert series at the Metropolitan
Museum of Art, New York, 1936

Together with the *Venus de Milo* and the *Mona Lisa*, the *Nike of Samothrace*, also commonly known as the *Winged Victory*, forms the holy trinity of the treasures at the Musée du Louvre. Referenced everywhere within the museum, it is one of the top destinations for the approximately ten million tourists who visit the Paris institution each year—a not insignificant figure, especially when one considers that its galleries contain some thirty-five thousand competing works of art.

A visual analogy par excellence for the concept of triumph, the *Nike* was discovered in April 1863 on the island of Samothrace by Charles Champoiseau, the French consul to Hadrianopolis. While engaged in his political activities, Champoiseau—like many colleagues stationed in the Hellenic region at that time—also cultivated a passion for archaeology. The statue was sent to Paris the same year, but it would be another sixteen years before it could be assembled in its current form, after Champoiseau, who had been transferred to Crete, returned to Samothrace and excavated some marble fragments that enabled him to reconstruct the pedestal, in the shape of a ship's prow, on which the sculpture originally stood. That discovery, together with the inscription "Rhodios" on the base, was fundamental for determining the *Nike*'s dating (ca. 295–287 BC) and attribution (probable artists include students of Lysippos or Skopas), and also clearly established the work's celebratory significance.

Despite the enthusiasm of scholars such as Wilhelm Fröhner, who considered the *Nike* to be comparable to the Parthenon sculptures in beauty and quality, the work might have been relegated to a minor role in the history of art were it not for a brilliant decision on the part of the Louvre administration. Officially exhibited for the first time in 1883, the sculpture spent a year in a dark corner of the Hall of the Caryatids before being moved to the top of the Daru Staircase. Its new position overlooking and dominating the space immediately restored the authority and prominence that had been so crucial to its original conception. As if to further accentuate its status as a divinity, the statue was later embellished with a supplementary pedestal, which increased its height and rendered it even more majestic.

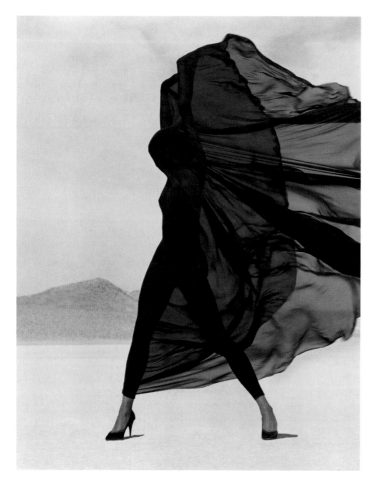

Herb Ritts
Versace, Veiled Dress, El Mirage, 1990

Cover of the Paul McCartney and Wings album *Wings Greatest*, 1978. Sleeve by Paul and Linda McCartney, assisted by Aubrey Powell and George Hardie

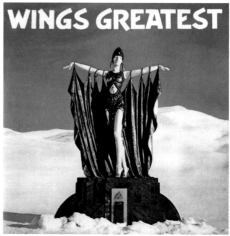

As with many other examples of Greco-Roman sculpture, great attention has been given to the missing portions, with particular speculation focusing on what the goddess may once have held in her hands. Some think it was a symbolic emblem of victory such as a crown, others propose a trumpet, and still others a metal *taenia*, or ribbon given to victors, clasped between index finger and thumb. In 1950 an expedition led by the German historian Karl Lehmann discovered the statue's left hand, albeit without the fingers. Lehmann's efforts, along with those of his wife, Phyllis Williams, made it possible to reconstruct the limb partially; it is now exhibited, complete with thumb and middle finger, in a display case beside the statue. In reality, it is likely that the *Nike* was never holding anything, and the debate has progressively dwindled in significance over the years. In the meantime, the lack of certainty has helped to emphasize the presence of the wings, an element that, in the modern era, has taken visual and imaginative precedence.

The frenzied climate that followed the Industrial Revolution and the machine-era rationalizations of the early twentieth century could not remain indifferent to an artifact that so effectively embodied ideals of power and superhuman qualities. Casts of the *Nike* began to proliferate in various corners of the Western world, and even Futurism, a movement inclined as few others to a thorough rejection of the past, reluctantly recognized the statue's importance. Umberto Boccioni's sculpture *Unique Forms of Continuity in Space* (1913) openly mimics the *Nike*'s headlong stance, while Filippo Tommaso

Marinetti, writing in his "Manifesto of Futurism" of 1909, cited the *Nike* as the banner of a classical culture that would be supplanted by the heroic new era of the machine gun and race car. Marcel Proust offered up the most excessive praise of the *Nike*, delegating to Madame Verdurin, one of the main characters of *In Search of Lost Time* (1913–27), the task of defining the statue, along with Beethoven's Ninth Symphony and Rembrandt's *Night Watch*, as one of the universe's supreme masterpieces.

In 1929 the French sculptor Abel Lafleur created the first trophy for soccer's World Cup; inspired by the *Nike*, it shows the winged goddess holding aloft an octagonal cup in a rare pastiche of Art Deco, Art Nouveau, and classicism. Indeed, once wartime exuberance subsided, it was the world of sports that repurposed the *Nike* as a symbol of highest achievement. In 1971 the American designer Carolyn Davidson created a logo for the company Blue Ribbon Sports that was inspired by the *Nike*'s silhouette. Rechristened the "Swoosh" because of its lightness, it was met with such a positive response that the clients decided to abandon the principle of comfort on which their company had been founded, in favor of dynamism and speed. In 1978 Blue Ribbon Sports renamed itself Nike, Inc., in honor of its muse. The same year, Paul McCartney chose for the album cover of the first greatest-hits anthology of his post-Beatles band, Wings, an aerial photograph of a small winged statue resting at the summit of a snowy alpine peak—a complex and rather unnecessary process that says something about the psychological, not just visual, influence that the *Nike*'s perceived omnipotence has transmitted over time.

Perhaps the contemporary image inspired by the *Nike* that has most successfully created an autonomous iconography is the shot of Leonardo DiCaprio and Kate Winslet poised on the prow of the *Titanic* in the film by James Cameron (1997). It is a perfect subliminal synthesis of all the semantic content that has made the inscrutable goddess famous: an impossible challenge that sometimes triumphs (like the love of the two protagonists) and sometimes ends in resounding defeat (as did White Star Line's ambitious ocean vessel).

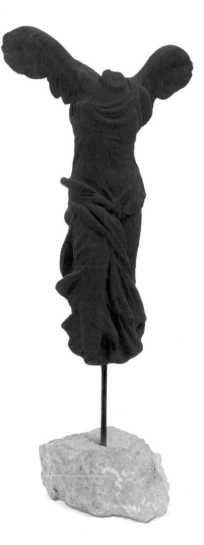

Yves Klein
Victoire de Samothrace, 1962
Pure pigment and
synthetic resin on plaster
mounted on a stone plinth,
50 × 26 × 36 cm
Private collection

VENUS DE MILO

ca. 200 BC Marble, height 204 cm — Musée du Louvre, Paris

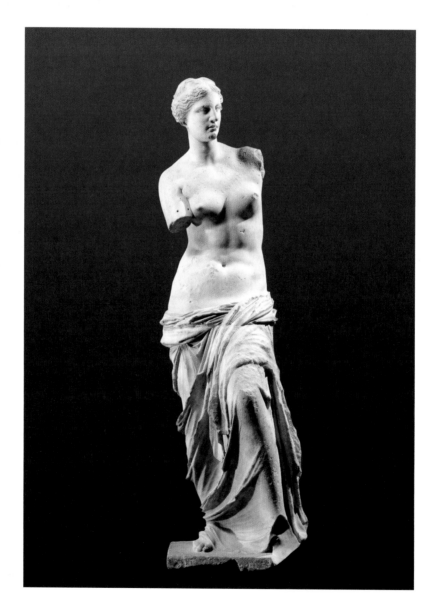

Among these statues
is one envied by all
the museums in Europe,
and which rightly passes
for the highest type of beauty,
for the most perfect realization
of the "eternal feminine."
Every one knows it is the
Venus of Milo.

...

Théophile Gautier

Venus lamp produced by Slide, 1998

Enveloped in a mantle of beauty and mystery that ob-scures a surprising variety of circumstances, from its an-atomical features to the identity of the artist to the way it was discovered, the *Venus de Milo* has made a deep impression on art history due to virtues that far exceed its unquestionable aesthetic qualities. In the spring of 1820, Yorgos Kentrotas, a peasant on the Greek island of Mílos, discovered the statue in a buried niche on lands belonging to Ludwig I of Bavaria. It had been readied for shipment to Prince Nikolaki Morusi, a high official of the Ottoman Empire in Constantinople, when Olivier Voutier, a French naval officer on the island at the time of the discovery, succeeded in taking possession of the sculpture; it was acquired, with the complicity of the vice-consul, on behalf of the French ambassador, the Marquis de Rivière. Rivière in turn made a gift of the statue to Louis XVIII, who donated it to the Musée du Louvre, where it was put on display in 1821.

Historical circumstances could not have been more propitious. Only a few years before, France had suf-fered a severe blow with the restitution of many works of art to Italy, including the celebrated *Medici Venus* by Cleomenes, son of Apollodorus, following the defeat of Napoléon. Fueled by the feelings of revenge that perme-ated the era, the French received the *Venus de Milo* with all honors and immediately extolled her as superior to the one that had been lost.

The results of this propagandistic exercise did not take long to come. Just one year later, a cast of the *Venus* was installed at the Academy in Berlin, and even Great Britain, a nation engaged in rivalry with France in both the cultural and the political arena, ended up placing a copy in the Greek court of the Crystal Palace in London's Hyde Park, alongside replicas of the *Discobolus*, *Laocoön and His Sons*, *Cleopatra*, and the *Barberini Faun*. Thus it was elevated to a primary role in the panorama of Greek sculpture, and as early as 1860 Samuel Phillips described it as "perhaps the most perfect combination of grandeur and beauty in the female form."

It was clearly impossible that such a masterpiece could be the work of anonymous hands, and the name of Praxiteles began to be circulated as the possible author.

Print ad for the "hands-free"
speakerphone, 1963

German poster for the film
Blonde Venus, 1932

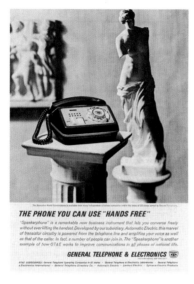

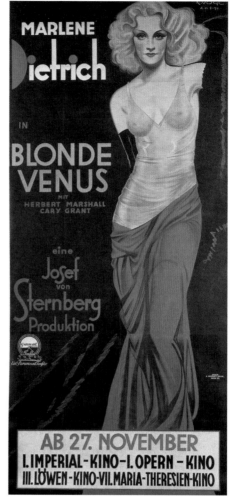

It was a fascinating hypothesis but one in clear contra-
diction to the simultaneous discovery of a marble base
that was a perfect fit with the *Venus* and that bore the in-
scription ". . . andros, citizen of Antioch of Maeander"—
a Hellenic city that was all but nonexistent at the time
of the great Athenian sculptor Praxiteles. Disputes
over the actual pertinence of the pedestal to the statue
started eroding the work's fame, and so the matter was
resolved with the sculpture's sudden yet extremely for-
tuitous disappearance from public view on the eve of its
official presentation. Germany did not hesitate to blame
the Louvre, though the curator there, Count Frédéric de
Clarac, was among those who had always maintained
that the pedestal belonged to the statue. In 1875 Karl
Baedeker's prestigious guidebook spoke of the *Venus*
as the "most celebrated of the treasures of the Louvre,"
which only encouraged its unstoppable ascent. It was
a course that could not be deterred by even the most
caustic comments, including a crusty remark by Pierre-

Auguste Renoir, who referred to it as being "as beautiful
as a gendarme," or one by historian Martin Robertson,
who condescendingly said that its "extraordinary reputa-
tion, which started by propaganda, has become perpetu-
ated by habit."

It is undeniable that the enigma of the work's
iconography, which has kept scholars busy for decades,
has only served to guarantee the *Venus* an immortal place
in the collective imagination. Many theories have been
advanced to explain the missing parts: she is a muse with
a lyre in her hand, a deity from the isle of Mílos, Aphrodite
holding Paris's apple. In the early 1980s, on the occasion
of an educational event where the Louvre invited the

Jillian Mayer
H.I.L.M.D.A., 2011
Still from video

public to propose explanations, one visitor left a laconic note: "She is serving a tennis ball." The infinite possibilities have unleashed the imagination of artists, directors, and advertising executives who have seen in the *Venus* an ambivalent duality of physical limitation and beauty. It is worth recalling Marlene Dietrich in Josef Von Sternberg's film *Blonde Venus* (1932), which surely inspired Charles Vidor's *Gilda* (1946), and later the character of Isabelle in Bernardo Bertolucci's *The Dreamers* (2003), whose long black gloves and sinuous silhouette directly recall the armless statue. Even John Huston, in his filmic homage to the Parisian bohemian tradition in *Moulin Rouge* (1952), has Henri de Toulouse-Lautrec speak of the work as a living entity during a visit to the Louvre. He describes it as "older than France, older than Christ, and yet no one knows anything more about her than that she was found in a cave by a peasant and sold to France for 6,000 francs." In 1963 General Telephone and Electronics of Stamford, Connecticut, used the *Venus* to publicize one of the first devices equipped with speakerphone ("The phone you can use 'hands free'"), reviving a concept expressed more subtly in one of the first advertising campaigns for Kellogg's Corn Flakes in 1910 ("If Venus had arms").

Following the lead of Man Ray in his portrait of designer Elsa Schiaparelli (1933), the *Venus* has been adopted by artists both as a feminist bulwark and as a symbol of disability, as in the images of Irish photographer Mary Duffy (*Cutting the Ties that Bind*, 1987) and in Jillian Mayer's video *H.I.L.M.D.A.*, shown at Art Basel Miami in 2011, in which the artist stages a performance in the guise of the famous statue, chewing off her arm bit by bit. Marc Quinn's portrait *Alison Lapper Pregnant*, by contrast, is slightly more conventional; exhibited in London's Trafalgar Square in 2005, the sculpture challenged the viewer by playing on the subtle line defining the figure's lack of limbs, producing a frisson of discomfort and aesthetic contemplation in the moment of transition from body to sculpture. All of which serves only to reinforce conventional wisdom that the *Venus de Milo*, like many similar works, would never have captured the collective imagination had she made it to our time in her complete form.

LAOCOÖN AND HIS SONS
Agesandros, Athanadoros, and Polydoros

ca. 42–20 BC Parian marble, 208 × 163 × 112 cm — Musei Vaticani, Rome

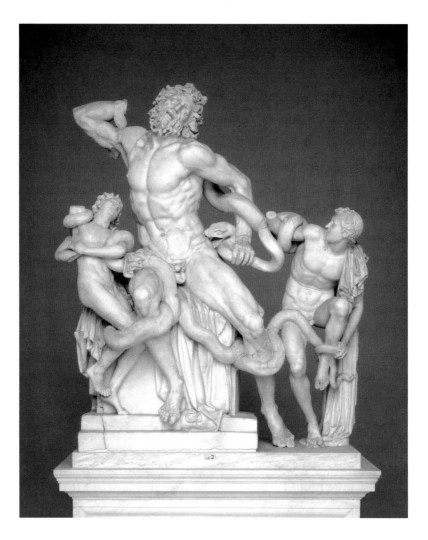

> And on the one hand
> the "artistic" quality,
> a decorative form evoking pathos,
> available for quotation and therefore
> also for metaphor, joke, irony;
> yet the formula has preserved
> its profound core of authenticity,
> of pain not only performed
> but consumed, of the spasm
> on the threshold of death.

Salvatore Settis

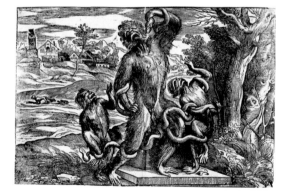

Niccolò Boldrini after a design
attributed to Titian
Caricature of the *Laocoön*, ca. 1540–45
Woodcut print, 27 × 40 cm
Civica Raccolta delle Stampe Achille Bertarelli—
Castello Sforzesco, Milan

Laocoön and His Sons was unearthed on January 14, 1506, in a vineyard near the Basilica of Santa Maria Maggiore in Rome. The discovery caused an immediate sensation and was celebrated in epigrams; recorded in the correspondence of ambassadors, prelates, and literary figures; and reproduced in drawings, prints, and paintings. Certainly it was a sculpture of extraordinary beauty, but the excitement over its discovery was amplified by its identification with a work that the Roman historian Pliny the Elder, in his *Natural History*, described as having seen in the villa of Emperor Titus. The prestige of this source, in an era that had seen a renaissance in the study and collecting of classical texts, thus conferred an even greater, almost mythical, resonance upon the sculpture.

The pope had an advantage over all potential buyers who came forward, and he placed the work alongside other marbles in the Vatican's Belvedere Courtyard, designed by Bramante and then under construction. It is said that during the sculpture's passage from the Esquiline Hill to the Vatican, it was pelted with flowers by onlooking crowds.

The sculptural group represents the mythological story of the Trojan priest Laocoön, who, with his two sons, was attacked by sea serpents—divine punishment, his fellow citizens believed, for having advised against allowing into the city the wooden horse left by Odysseus at the gates of Troy.

The dating of the work has been the subject of debate and ranges from the mid-second century BC to the mid-first century AD. But the most reliable hypothesis dates the work around 42–20 BC, with attribution to three Greek artists, Agesandros, Athanadoros, and Polydoros, from a workshop in Rome. Though it was not well known at the time it was sculpted, perhaps because it was located in the exclusive imperial villa and consequently almost never copied, Renaissance replicas were made in all sizes and materials: wax, stucco, bronze, semiprecious stones, terra-cotta, and even plates sold as souvenirs. The most colossal copy, the first at the true scale of a large ancient sculpture, was created for King Francis I of France, but Pope Clement VII decided to keep it for himself.

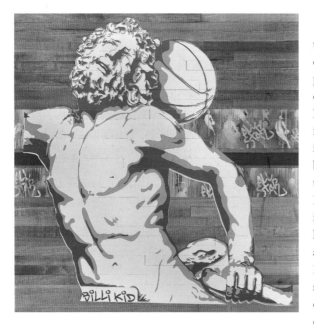

Billi Kid
*Beware of Players
Bearing Gifts*, 2011
Aerosol spray stencil over a
section of the NBA All-Star
Game Basketball Court,
122 × 122 cm

Satirical cartoon of Richard
Nixon as the *Laocoön*
(artist unknown), reproduced
in the exhibition catalogue
The Trivial Afterlife of Antiquity
(Kunsthalle Basel, 1974–75)

In the neoclassical era the work's fame never waned, thanks largely to the writings of two Germans: the archaeologist Johann Joachim Winckelmann and the philosopher Gotthold Ephraim Lessing. Another great contribution to its celebrity came during the reign of Napoléon, the only sovereign who succeeded in removing the masterpiece from the pope's possession. He had it brought into Paris in a triumphal procession in 1798, but his conquest was ephemeral; after the restoration of the Bourbon monarchs the *Laocoön* returned to Rome. Both journeys gave the sculpture enormous popular visibility, and it went from being a symbol of grief par excellence to one that also assumed political value, becoming a metaphor first for triumph and then for the fall of the French empire. This was a shift in significance that persisted until the early twentieth century, when the German critic Karl Scheffler, in his review of an 1898 exhibition of the Secession in Berlin, recalled the dichotomy in Lessing's famous treatise *Laocoön* to argue that the artists of the Secession were arriving at an art of dramatic content, much closer to the Germanic temperament than to the light, lively attitude of French Impressionism. This, then, was another appropriation with nationalistic undertones.

By this point the evocative political power of the *Laocoön* had become so universal that the work could again be quoted subliminally in 1974 at the Kunsthalle Basel, where a cartoon was exhibited depicting former American president Richard Nixon fighting snakes in the form of magnetic tape—an allusion to the Watergate scandal and Nixon's resulting resignation.

Between 1957 and 1959 the statue had experienced a renewed surge of interest on the occasion of its restoration. It was then that the priest's missing arm, unexpectedly discovered in 1905 by the archaeologist Ludwig Pollak in the workshop of a Roman stonecutter, resulted in the rethinking of the positioning of that appendage. The world's fascination with the reconstruction (which confirmed that the arm should be bent back rather than extended upward) was enhanced by the discovery, in the so-called Grotto of Tiberius in Sperlonga, Italy, of a group of sculptures that were stylistically similar to

Poster for the film *Saturday Night Fever*, 1977

"*Laocoön* and Rheumatic Pain," from the medical journal *Praxis-Kurier*, 1964

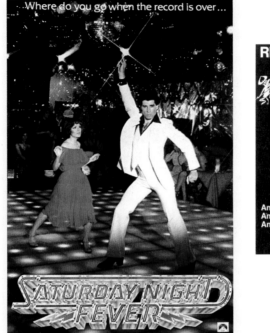

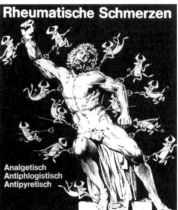

the *Laocoön*. One of them bore the chiseled signature of Agesandros, Athanadoros, and Polydoros, the very same Greek sculptors to whom Pliny had attributed the *Laocoön*.

It was an extraordinary find. And yet the names of the sculptors never became as popular as the artwork itself, perhaps because, as Pliny had astutely written: "The fame of many is not great, for in certain instances the number of artists involved stands in the way of their achieving individual renown even in the case of outstanding works, since no single person received the glory and since many names cannot all be recognized equally. Thus it is with the Laokoön." Indeed, three factors converged to give the *Laocoön* its iconic status: the prestige of the historical source (Pliny), the stature of the work's owners (Emperor Tiberius, then the popes), and its place of exhibition (the Belvedere Courtyard, an indisputable seal of approval). The extent of its universal celebrity may be measured by the fact that as early as the seventeenth century, there were a burgeoning number of copies of just the head of the Trojan priest. It was the part that, by immediate

association, referred back to the whole; constituting the ultimate expression of grief, it was often mimicked by artists in sacred depictions, such as the faces of martyred saints. Titian, Rubens, and many other painters owned plaster casts that they used as models.

Although the names of the *Laocoön*'s creators did not help establish its mythic status, we nonetheless see the sculpture coupled, almost immediately, with another fundamental indicator of an artwork's fame: receptiveness to caricature. Just a few years after the statue's discovery, a print appeared, attributed to Titian, in which the priest and his sons were transformed into monkeys. Advertising and political journalism also desecrated the icon, as, for example, in a 1964 issue of the German medical journal *Praxis-Kurier*, where the statue stands in as a parodic manifestation of rheumatoid pain. Having entered the common visual language of Western culture, the *Laocoön* can even be detected in the poster for *Saturday Night Fever* (1977), where John Travolta poses with his arm raised in the same position as the missing limb in early restorations.

BIRTH OF VENUS
Sandro Botticelli

ca. 1484 Tempera on canvas, 172 × 278 cm — Galleria degli Uffizi, Florence

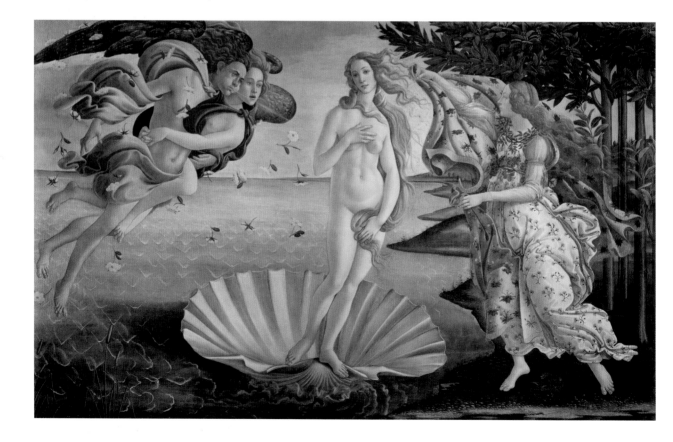

The long-limbed female type, unstable, with a small nose, a triangular chin, a distant glance, seems to await in this fragile and graceful art the arrival and poetic gift of Botticelli.

André Chastel

SCANDALE
GAINES · CEINTURES · SOUTIEN-GORGE

Ad for Scandale by S. N. Lesage, 1955

Although today it is one of the most famous paintings in the world, the *Birth of Venus* by Sandro Botticelli (ca. 1445–1510) was virtually unknown until 1815, when it was first exhibited at the Galleria degli Uffizi in Florence. Its popularity with the public at large is a much more recent phenomenon related to the explosion of the "fashion system" in the 1980s, when the image of Botticelli's *Venus* became shorthand for conferring a classical, mythological aura on the blond supermodels of the moment.

Despite the fact that it was the fashion industry that ultimately transformed the *Birth of Venus* into an icon, even modern sacred images require a mythography. Playing an equally important role was the halo of mystery that surrounds the name of the patron, the date and occasion for which the canvas was painted, and even the subject of the work. Scholars have spilled rivers of ink to support numerous hypotheses and display their erudition in the most disparate interpretations. What they all agree on is that the work was commissioned by a member of the Medici family (precisely whom we do not know), for the three orange trees on the right are an emblem of that dynasty.

There is a vast body of literature on the iconography of the painting (though less than found on Botticelli's *Primavera*). Derived from Greek and Latin literature, particularly Ovid's *Metamorphoses* and an unfinished fifteenth-century poem by Politian in honor of Giuliano de' Medici, the story is that of Venus Anadyomene ("Venus Rising from the Sea"), to whom one of the three Hours (divinities of the Seasons, daughters of Zeus) offers a cloak as she is driven ashore by the breath of the springtime winds, Zephyr and Aura. She is about to land on the island of Cyprus, or in Sicily, or perhaps in Portovenere, the city of Simonetta Vespucci, a young woman beloved by Giuliano de' Medici and, according to some, recognizable in the features of the Venus figure. Other scholars have connected the painting to the arrival of a bride, to the birth of an heir (a baby girl named Margherita, like the flowers that decorate the mantle about to envelop the goddess), or, more generally, to the beginning of a "reign of love" in a peaceful and prosperous Florence under the rule of the powerful Medici family.

According to Neo-Platonic interpretations, the subject symbolizes the birth of Humanitas, generated by the four elements and the union of spirit and matter. The first person to mention the painting was Giorgio Vasari, who wrote in 1550 that he had seen it, along with *Primavera*, in the Villa di Castello, in the hills outside Florence, which belonged to Lorenzo and Giovanni di Pierfrancesco de' Medici. Botticelli was much admired during his lifetime, but only a few years after his death Vasari gave him scant praise; he viewed Botticelli as an artist who belonged to the fifteenth-century world of small figures and rigid perspective, a world swept away by the "grand style" of Leonardo, Raphael, and Michelangelo. It was a judgment that was shared in 1598 by officials in the employ of the Grand Duke of Tuscany, who completely ignored Botticelli in their inventory of works worthy of preservation.

Tomoko Nagao
Botticelli—The Birth of Venus with Baci, Esselunga, PSP, and EasyJet, 2012
Digital work, ed. 5,
100 × 210 cm
Private collection

"Your Wednesday rendezvous with culture" is the claim in this 2013 ad for *Le Mad*, a cultural supplement of the Belgian daily *Le Soir*.

The *Birth of Venus* remained in the Medici villa, hidden from view, until at least 1761. In 1815, when it was moved to the Uffizi, it was met with general indifference. Decades later, a decadent and romantic reinterpretation led English critic John Ruskin and his Pre-Raphaelite friends to reverse the painting's fortunes, ushering in a renewed interest in the painter. Romanticism saw in Botticelli a neurotic, dreamy, and morbid personality, tragically involved in a profound mystical crisis that coincided with Savonarola's fanatical preaching against art and pleasure, which drove the artist to practically cease painting.

Thanks to this sort of mythography, which would only be accentuated by Decadentism, the *Birth of Venus* became increasingly known in cultural and literary circles. In 1873 the influential Walter Pater sparked the public imagination with indulgent interpretations such as: "He paints the story of the goddess of pleasure in other episodes besides that of her birth from the sea, but never

lemad
Votre rendez-vous culturel du mercredi.

without some shadow of death in the grey flesh and wan flowers. He paints Madonnas, but they shrink from the pressure of the divine child, and plead in unmistakable undertones for a warmer, lower humanity."

Thus a precise historical moment sealed the fate of an aesthetic model. Much as Botticelli's *Venus* was admired by the Romantics for her quintessence and melancholy, she is a touchstone of pop culture today because she corresponded so well with the ideal female body of the late twentieth century: blond, thin, long-limbed, with a vague quality that is simultaneously subdued and glamorous, like the heroines in comic strips or on billboards. It is a revival that, for the umpteenth time, coincides with a zeitgeist. On the one hand, fashion has remade itself in the image of a Botticelli, deliberately exploiting the quality of "high art"; on the other, certain physical types, gestures, poses, and windblown hair have contributed subliminally to the ongoing evocation of Venus, from the pages of newspapers to posters advertising clothing, perfumes, lingerie, and the like—putting into practice the teamwork usually required in the birth of an icon.

LAST SUPPER
Leonardo da Vinci

ca. 1494–98 Tempera and oil on plaster, 460 × 880 cm
— Refectory of Santa Maria delle Grazie, Milan

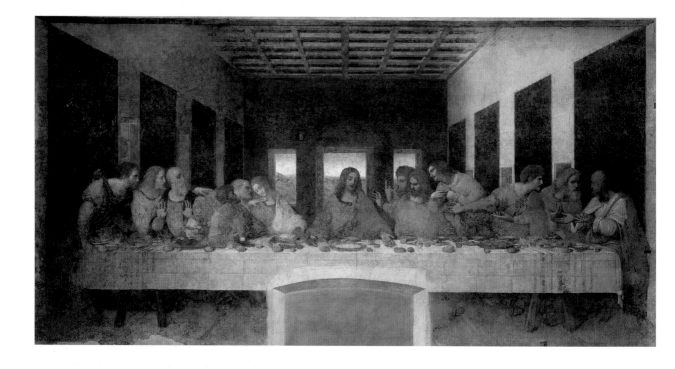

**Lovers move toward
the simulacra
of beloved things,
to converse with
the imitated forms.**

Leonardo da Vinci

The *Last Supper*, frescoed by Leonardo da Vinci (1452–1519) in the refectory of Santa Maria delle Grazie in Milan, was the first painting in history to be duplicated and disseminated through the first tool of mass reproduction—the engraving. It is a technique that, until that time, had never been used to make copies of already-existing works, only to print original images. Indeed, such was the clamor aroused by the *Last Supper*'s novelty that a market immediately emerged for engravings of the work, for the most part sold to artists but also to cultivated travelers who wanted a souvenir of the painting, much as postcards are used today. The testimony of Antonio de Beatis, who visited the *Last Supper* in 1517 in the company of the cardinal of Aragón, describes how the monks of Santa Maria delle Grazie were even then besieged by requests from those who wished to admire the fresco.

In 1870 Henry James wrote in the *Atlantic Monthly* that Leonardo's *Last Supper* was the first Renaissance masterpiece that one encountered upon descending into Italy from northern Europe, granting the painting extraordinary emotional value for the traveler. Goethe considered it "the veritable keystone in the vault of artistic conception," but there was no shortage of detractors with two intended targets: the artistic myth of the highest example of civilization, the Renaissance; and, particularly in Protestant countries, the Eucharist, which represented Catholic dogma at its most extreme.

Over the course of the nineteenth century, the widespread dissemination of the *Last Supper* on the walls of every Catholic home, as well as its indiscriminate use in holy images, where the composition was mutilated, added to, or collaged with other devout scenes (such as, for example, the Stations of the Cross), resulted in the profound aversion of intellectuals. Bernard Berenson, the great American connoisseur who had a particular passion for Tuscany, deplored the Leonardo fresco: "What a pack of vehement, gesticulating, noisy foreigners they are, with faces far from pleasant, some positively criminal, some conspirators, and others having no business there." It is an exaggeratedly malevolent judgment, but predictable on the part of someone who saw elite taste

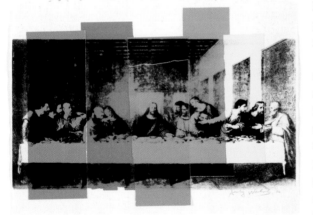

Andy Warhol
The Last Supper, 1986
Screenprint and colored graphic art
paper collage on paper, 60 × 80 cm

"Leather *Last Supper*" poster for the Folsom Street Fair, an annual BDSM and leather subculture event in San Francisco, 2007

Ad for an online betting agency depicting Jesus and the apostles playing cards at a gambling table, 2005. The company was forced to pull the campaign following a large volume of complaints.

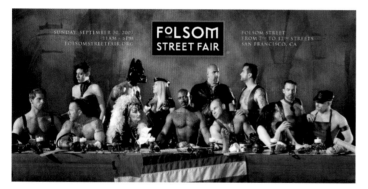

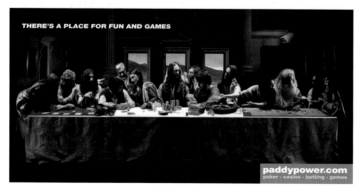

threatened by a popular culture that was appropriating and desecrating models of high culture. Around 1850 John Everett Millais painted a portrait of Eliza and Sarah Wyatt in their tidy little bourgeois parlor; above them hangs a reproduction of the *Last Supper* alongside reproductions of Raphael's *Madonna of the Chair* and *Alba Madonna*. There are similar scenes by Sebastian Gutzwiller (*Basel Family Concert*, 1849) and Christian Krohg (*The Net Mender*, 1879)—typical examples of the kind of popular and petit bourgeois appropriation of Renaissance masterpieces that horrified snobs like Berenson.

To understand the *Last Supper* as palimpsest, one must begin with the original, which Leonardo modified continuously, seriously testing the patience of his patrons. A few years after he finally completed it (the date recorded as February 9, 1498), the fresco had already begun to deteriorate. This explains many questionable additions to the reproductions by copyists, many of whom had never even been to Milan and made their own personal revisions to gaps produced over the centuries by atmospheric degradation and war. The restorers who in turn intervened on Leonardo's work, influenced by the copies, made many of the same additions. In other words, conservators and copyists became cogs in a monstrous circular mechanism that fed off itself.

That is why, from Leonardo to *The Simpsons*, the *Last Supper* can be considered an unfinished and infinite work—a collective icon written and rewritten throughout the centuries. Its iconographic power stems, paradoxically, from its having been, in Théophile Gautier's words, "the ghost of a masterpiece"—the specter of an artwork in which what is missing is in fact Leonardo's original, upon which everyone projects his or her own vision, religious or blasphemous. This is exactly what happens with all idols consecrated by collective worship. In the decadent imagination, the ghostly *Last Supper* became the twin of the equally enigmatic and elusive *Mona Lisa*.

Renee Cox
Yo Mama's Last Supper, 1996
Photograph, five panels,
each 78 × 78 cm

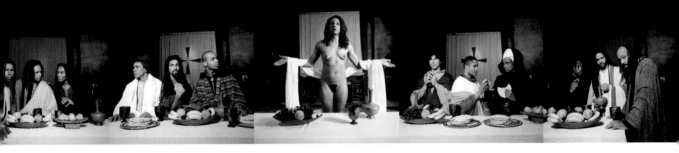

Further proof of the *Last Supper*'s iconographic power may be found in its caricatures, which were often made with the intent to profane. As early as the eighteenth century, William Hogarth, an anti-Catholic, made works attacking the institution of the Eucharist in the *Last Supper*. But it was the twentieth century that gave us the most sacrilegious and satirical interpretations of the work, beginning with cinema, as in Luis Buñuel's *Viridiana* (1961), Pier Paolo Pasolini's *Mamma Roma* (1962), Robert Altman's *M*A*S*H* (1970), and Mel Brooks's *History of the World: Part I* (1981). In the visual arts, Mary Beth Edelson created a feminist version in 1972, replacing the faces of the participants with those of important women artists. The Christ figure is also a woman, more specifically a self-portrait, in a work by Renee Cox, who appears nude, surrounded by twelve black apostles, in *Yo Mama's Last Supper* (1996), which was censored by Rudolph Giuliani, the then mayor of New York, when it was exhibited at the Brooklyn Museum of Art. Far from depleting the icon, its indiscriminate deployment in advertising and merchandising has consolidated the communicative power of the image, which has withstood every assault of kitsch culture.

Yet among all the reworkings of the *Last Supper*, the one that remains exemplary is the clever iconographic use to which Andy Warhol put it in his last exhibition before his death. Held in Milan in January 1987, and specifically inspired by the theme of the *Last Supper*, the show consisted of eight large silkscreens of a photograph of a nineteenth-century reproduction that the artist had purchased in a Korean religious shop in New York. Warhol's idea was to work on the added value of Leonardo's image. Producing multiple reproductions of a photo of a copy that was itself a copy of the original only served to confirm the *Last Supper*'s fetishistic value. Like miraculous images, the image-icon does not need to be authentic in order to become a fetish and exercise its power of attraction for the public. Warhol thus revealed the inherent quality of Leonardo's *Last Supper*: its existence as an image that can always be interpreted, modified, and reproduced. It is a fetish for mass veneration, one whose fame has grown more through imitation than through direct observation of the original.

MONA LISA
Leonardo da Vinci

ca. 1503–6 Oil on poplar panel, 77 × 53 cm — Musée du Louvre, Paris

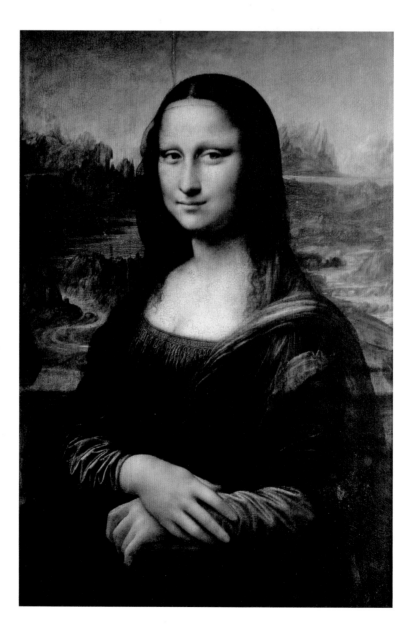

Before [Leonardo] portraits lack mystery; artists depicted only soulless external forms or, when they characterized the soul itself they sought to reach the viewer through gestures, symbolic objects, writings. Only enigma emanates from the *Mona Lisa*: the soul is present but inaccessible.

Charles de Tolnay

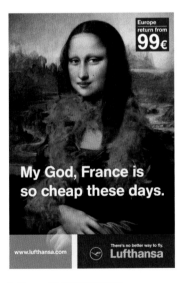

Mystery. This is the principal reason for the success of the small panel by Leonardo da Vinci (1452–1519) that is known in France as the *Joconde*, in Italy as the *Gioconda*, and in the rest of the world as the *Mona Lisa*.

First there is the mystery of the smile, to which innumerable meanings have been assigned. Then there is the mystery of the work's execution: When was it painted? And for whom? But above all is the mystery of the subject's identity.

In 1550 Giorgio Vasari very clearly wrote that "Leonardo undertook to paint, for Francesco del Giocondo, the portrait of Monna Lisa, his wife," yet for centuries historians, novelists, and dreamers ran amok in search of the most improbable solutions to the *Mona Lisa*'s identity. Finally, in 2007, Giovanni Pallanti put an end to the enigma when he found, in Florence, the baptismal and death certificates for Lisa Gherardini, wife of the Florentine silk merchant Vasari had described as the painter's client. So actually there had never been a mystery about the identity of the subject, no matter how much everyone desired one.

Since its appearance, the *Mona Lisa* has been perceived as an astounding innovation, most particularly for its combination of portraiture and landscape and for the direct relationship the portrait establishes between the subject and viewer. In this regard, art historian Martin Kemp has written, "Leonardo is playing upon one of our most basic human instincts—our irresistible tendency to read the facial signs of character and expression in everyone we meet. We are all intuitive physiognomists at heart."

Beyond its aura of mystery, the *Mona Lisa*, like *Laocoön and His Sons*, is one of those works that have become icons in part thanks to a prestigious provenance (in this case royal). Most Italians are convinced that Napoléon stole the painting, along with others now in the Musée du Louvre, yet it was, in fact, rightfully acquired by King Francis I of France, for whom Leonardo was working when he died.

Though always considered a masterpiece, the *Mona Lisa* did not initially enjoy the same popularity as Leonardo's *Last Supper*. Whereas the latter was frescoed on the wall of a monastery kept open to the public, the small portrait

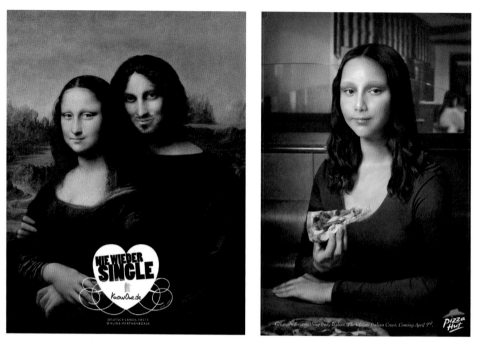

Ad by schwarzspringer
for the German online-dating
service Know One, 2007

Pizza Hut's "Get ready for
something truly Italian"
ad by Ogilvy & Mather Kuala
Lumpur, 2003

remained closed off in the royal collections. In 1797 it was put on a list of paintings intended for the core collection of the new Musée du Louvre, but in 1800 Napoléon had the panel moved to his bedchamber at the Tuileries Palace. It was not delivered to the Louvre until 1804.

Also unlike the *Last Supper*, reproductions of the *Mona Lisa* were rarely printed and were very difficult to create due to the painting's subtle tonal transitions (the famous "Leonardesque *sfumato*"). There wasn't an explosion of "Giocondomania" until the second half of the nineteenth century, and even then it took the theft of the painting—on August 21, 1911, by Vincenzo Peruggia, an Italian housepainter who was working in the museum—to give a final push to the work's now well-established fame. The *Excelsior*, one of France's most important newspapers, announced the theft on its front page of August 23, 1911, publishing an image of the painting alongside the faces of the Louvre's then director, Théophile Homolle (who was forced to resign in disgrace), and the chief of police. *Le Petit Parisien*, which sold 1.4 million copies a day, came out with an enormous photo on the front page and a banner headline: "The *Mona Lisa* Has

Disappeared from the Musée du Louvre." The September 23 issue of *L'Illustration* also presented readers with a reproduction of the *Mona Lisa*. The occasion of the theft thus became an extraordinary opportunity for the popular dissemination of the painting's image, the biography of the artist, and the story behind the subject's enigmatic smile. When the Louvre, which had been closed in the wake of the theft, reopened on August 30, Parisians turned out en masse to contemplate the empty wall.

The media effect came full circle when Vincenzo Peruggia smuggled the painting to Italy and tried to sell it to a Florentine antiquarian, Alfredo Geri, who immediately alerted the authorities. The *Mona Lisa* was returned to France after a two-day mini-tour during which it was exhibited at the Galleria degli Uffizi in Florence, the Galleria Borghese in Rome, and the Pinacoteca di Brera in Milan, where people thronged the surrounding streets. The press throughout Europe once again became a sounding board, publishing photographs and articles. Journalists, writers, cabaret performers, actors, and humorists had a field day: one satirical postcard was printed with the words "I am going to find my da Vinci"

(another, after the painting was found, showed the *Mona Lisa* returned to Paris, handcuffed between two policemen). The magazine *Comoedia Illustré* published images of the twelve most famous Parisian actresses, from La Belle Otéro to Mistinguett, dressed like the *Mona Lisa*, captioned "the smiles with which we are left." Political propaganda also appeared—a 1918 postcard was printed with a Kaiser *Mona Lisa*, followed by a Stalin version. And though the advertising industry had only rarely used the *Mona Lisa* prior to its theft, it was thereafter exploited to promote a wide range of products. Donald Sassoon, citing research by Jean Margat, maintains that during the 1970s one could count on average twenty-three instances of its use every year—a number that more than doubled in the 1980s and 1990s.

According to a proven mechanism that befalls great icons, the increase in fame was also accompanied by an opposite reaction. William Hogarth, in a 1735 portrait had already transposed his mother's sullen, masculine face over that of the *Mona Lisa*, but the true demolition of the myth may be credited to Marcel Duchamp, who in 1919 drew a moustache and goatee on a reproduction of the painting, completing the sacrilegious act by adding the letters *L.H.O.O.Q.*—which, when pronounced in French, sounds like *Elle a chaud au cul* ("She has a hot ass"). Since then, artist Salvador Dalí, filmmaker Henri Gruel, forensics scientist Matsumi Suzuki, and many others have dedicated themselves to profaning the symbol of beauty. In 1990 the French body artist Orlan joined their numbers when she underwent plastic surgery to modify her forehead to look like that in the *Mona Lisa*.

Many songs have named the icon, from "You're the Top," a 1934 song by Cole Porter; to "Mona Lisa," by Jay Livingston and Ray Evans, made famous by Nat King Cole in 1950; to Bob Dylan ("Visions of Johanna," 1966) and Elton John ("Mona Lisas and Mad Hatters," 1972). And the Louvre and the French Ministry of Culture, for their part, have also exploited the painting's fame for commercial ends—amplifying its notoriety, of course, in the process. The enigmatic face graces the cover of the museum's guidebook; it appears on every page of its website; and merchandising of the image has systematically increased, from espresso cups to handbags and barrettes.

DAVID
Michelangelo Buonarroti

ca. 1504 Marble, height 410 cm — Gallerie dell'Accademia, Florence

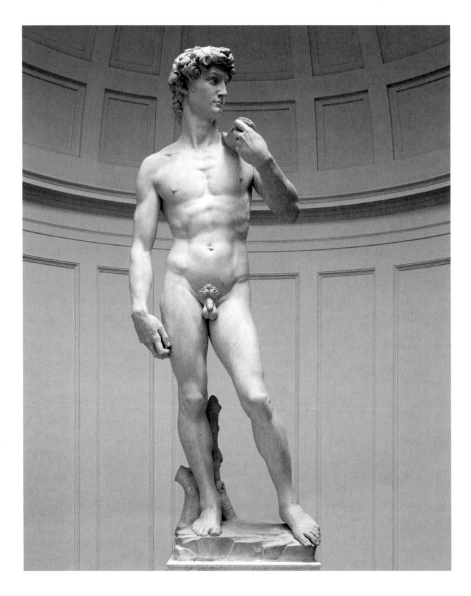

**And truly may we affirm
that this statue
surpasses all others,
whether ancient or modern,
Greek or Latin.**

Giorgio Vasari

The cult of personality surrounding Michelangelo Buonarroti (1475–1564) began with this statue of white Carrara marble. More than four meters high, it was the first large-scale male nude since the time of the Greeks and Romans. Two icons thus emerged with the *David*: one an ideal representation of male beauty and the other a titanic Renaissance genius who surpassed the incomparable art of the ancients. It is no accident that Michelangelo was the only artist of the sixteenth century to be the subject of three biographies during his own lifetime (written, respectively, by Paolo Giovio, Giorgio Vasari, and Ascanio Condivi).

On August 16, 1501, the artist signed a contract with the wool guild and representatives from the Opera del Duomo to use a block of marble that had been brought from Carrara to Florence in 1464 by Agostino di Duccio, an artist who had failed to extract a sculpture from the material. In 1476 the marble passed into the hands of another sculptor, Antonio Rossellino, again in vain, and it remained abandoned in the courtyard of the Opera del Duomo. Thus, from the start, the *David* existed in Michelangelo's mind as an act of pride and a challenge to

all who had been unable to utilize that block of marble before him.

The chisel struck its first blow in September 1501; in January 1504 the project was completed. The artist was twenty-eight years old and from then on was idolized as "divine."

On September 8, 1504, the statue was installed alongside the doorway of Florence's Palazzo Vecchio, where it remained until 1873, when it was moved to the Accademia and a copy was placed in the Piazza della Signoria.

If on the one hand the *David* represents the highest embodiment of the heroic and classical ideal of the Renaissance, at the same time it is the first statue in which Michelangelo shattered the perfection of classical canons. He achieved this through an elongation and tension of the anatomy, introducing into that apparent harmony an imbalance that imperceptibly shifts the emphasis from physical beauty to an aspect of psychology, making the heroism of the figure seem fragile.

One of the first casts made from this colossal statue, and the first to reach England, was shipped to Queen Victoria by the Grand Duke of Tuscany in 1856. It was a

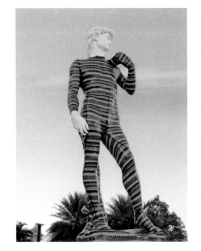

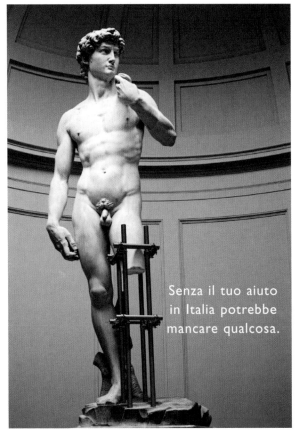

Senza il tuo aiuto in Italia potrebbe mancare qualcosa.

gift meant to compensate for the "discourtesy" of the Tuscan government, which had vetoed the sale of a Ghirlandaio painting that the English wished to purchase. It seems that the queen did not particularly appreciate the exuberant nudity of the *David*; though the young hero's genitals were covered with a marble fig leaf, she ordered that the statue be sent to the Foreign Office. It should also be kept in mind that by the seventeenth and eighteenth centuries, the *David*—though celebrated in the sixteenth century, above all by Vasari—was less famous than Michelangelo's *Bacchus*, *Risen Christ*, or *Moses*. It enjoyed less prestige than statues installed in places that signaled the ultimate in taste, such as the papal garden of the Belvedere in Rome (site of *Laocoön and His Sons*) or the Tribuna at the Uffizi in Florence (which boasted the *Medici Venus*).

David's renewed fame in the twentieth century started with an enthusiasm for physical rather than moral strength. Studies published on the occasion of a 2006 Florentine exhibition dedicated to the sculpture identified two key moments that served to emphasize the superman qualities of Michelangelo's hero. The first, in 1909, was its reinstallation in the Accademia at the end of a corridor with a row of Michelangelo's *Captives* (imposing unfinished sculptures of men seemingly imprisoned in marble). It is a dramatic perspectival view leading directly to the *David*, which appears as a sort of liberating and triumphant hero. The second crucial moment had to do with the development of American military power in more recent years, with the myth of the *David* exploding in direct proportion to the increasing number of visitors to the Accademia from the United States.

The work's fame grew further after the 1960s, thanks in part to a gay aesthetic that resulted in open-minded versions by Andy Warhol (an obsessive sequence repeating a detail of only the genitals and fist) and David Hockney (who photographed the legs of a model in the shower, striking the same pose as the marble statue).

Thanks in large part to the ways in which artists have

used this Renaissance masterpiece to chal-
lenge themselves, the sculpture has become
extremely popular, including with the pub-
lic at large. For an exhibition organized by
the Accademia in honor of the *David*'s five
hundredth anniversary in 2005, the German
artist Thomas Struth emphasized the work's
fetishistic quality. He therefore photographed
not the *David* but rather the public looking
up at "this statue [that] surpasses all others"—
to the extent that it need not even appear
in the image. It is as if to say that the myth
of the *David* goes beyond the image of the
David itself. For the same exhibition, Robert
Morris, in a video entitled *The Birthday Boy*,
made a version of the *David* wearing military
trousers and positioned in front of a row of
tanks. According to the artist, beneath "the
kitsch image the *David* embodies there lies at a deeper
level an aesthetic allegory of Western power driven by
whiteness, maleness, and militaristic predilection"—a
mirror of the macho nature of American society. By con-
trast, *Time* magazine made the work a symbol of Italy in
crisis, depicting the statue arm wrestling with a Chinese
terra-cotta warrior on a cover bearing the title "Italy vs
China" (December 5, 2005).

In 2006, in the Los Angeles exhibition *Barely Legal*, the
controversial British artist Banksy showed a resin cast of
the sculpture wearing a bulletproof vest, as if to suggest
that war is a commercial business that has replaced the
ideals of the past, precisely as plastic souvenirs for sale
in museums have become surrogates for original works
of art. Banksy's gesture thus further upsets the *David*'s
meaning. Appearing with ridiculously naked genitals
beneath a bulletproof vest, his hero is the opposite of
macho—he is a low-cost tchotchke for sale.

And yet it is precisely this ongoing shifting of meaning,
even into the realm of outrage and ridicule, that con-
firms the power of Michelangelo's icon—an image so fa-
mous that its symbolic impact, even when manipulated,
is constantly capable of generating new interpretations.

Andy Warhol
Jean-Michel Basquiat, 1984
Synthetic polymer paint
and silkscreen ink on canvas,
229 × 178 cm

"Too bad he didn't eat at Freshii"
was the tagline in this 2010
commercial for the health-food
chain restaurant Freshii.

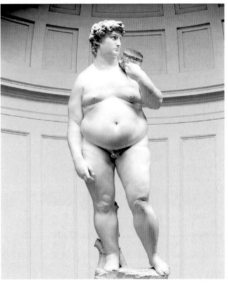

CREATION OF ADAM
Michelangelo Buonarroti

ca. 1511 Fresco, 280 × 570 cm — Sistine Chapel, Vatican City, Rome

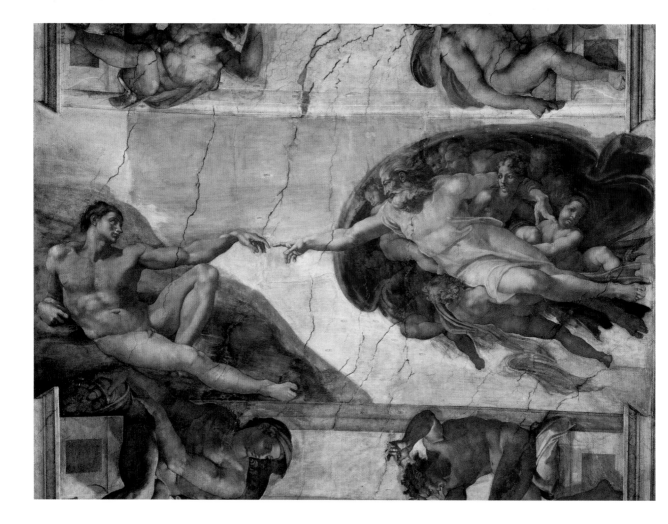

When [Michelangelo] was making an arm or a leg, it seems as if he were thinking only of that arm or leg and was not giving the slightest consideration to the way it relates with the action of the figure to which it belongs, much less to the action of the picture as a whole.... Therein lies his great merit; he brings a sense of the grand and the terrible into even an isolated limb.

Eugène Delacroix

Caravaggio
Calling of Saint Matthew, 1598–1601
Oil on canvas, 322 × 340 cm
Church of San Luigi dei Francesi, Rome

The *Creation of Adam* is one of nine scenes of stories from Genesis that make up the ceiling of Rome's Sistine Chapel, measuring more than a thousand square meters. Michelangelo began working on the project in 1508 at the behest of Pope Julius II; he completed the ceiling in 1512, having painted some three hundred figures.

The *Creation of Adam* is located almost at the center of the ceiling, and the gesture of God the Father is one of the most audacious ideas of this Florentine genius. The scriptures, in fact, do not indicate that God created Adam by a touch of his finger, but rather that he shaped a figure from earth and breathed life into it.

According to statements written at that time, the unveiling of the vault immediately aroused amazement and admiration, but judging from the scant printed reproductions (which functioned as a measure of a work's popularity, much as photographs do today), it does not appear that the project won widespread approval. However, it bears noting that Michelangelo disdained the dissemination of his work through engravings—unlike his rival Raphael, who skillfully and craftily used them as a means to amplify his fame.

The first more or less complete series of reproductions of the seers, prophets, sibyls, and nudes crowding Michelangelo's vault was engraved in 1541 by Adamo Scultori, who worked on a small scale (ten by fourteen centimeters). But there was still little interest in the central scenes of the biblical stories, the most appreciated of which were the *Flood* and *Creation of Eve*.

Copies of the ceiling began to circulate in greater number only in 1541, after Michelangelo completed his second Sistine fresco, the *Last Judgment*, on the back wall. As this work attracted more acclaim, it also drew greater attention to the ceiling frescoes. The Sistine Chapel became a sort of drawing academy where painters from around the world came to copy Michelangelo's frescoes in person, not only to practice from the greatest of all models but also to create reproductions on commission from collectors.

The nineteenth century finally saw the arrival of photography, which gradually came to replace engravings. Until that time, copies of the ceiling were for the most

part limited to individual details. But Adolphe Braun & Co., Borgi and Alinari, and Anderson waged large-scale photographic campaigns in 1868–70, 1870–80, and 1933, respectively. Photographic reproduction ultimately prevailed over manual copies, though the latter continued to be made, becoming increasingly interpretative in works by artists such as Delacroix, Géricault, Moreau, Rodin, Klee, Picasso, and Pollock.

Yet the unprecedented iconography of the *Creation of Adam*—of two fingers lightly touching, transmitting life—remained difficult for people to understand. Michelangelo's biographer and contemporary Ascanio Condivi read God's gesture as a warning rather than a creative act: "God is seen with arm and hand outstretched as if to impart to Adam the precepts as to what he must and must not do." The gesture was even misinterpreted by Caravaggio, who borrowed it in his *Calling of Saint Matthew* (1598–1601) for the church of San Luigi dei Francesi in Rome. The Christ figure who points to

Matthew precisely replicates Adam's gesture, but for Caravaggio the gesture is a generic act of indication—the pointed index finger that serves, in theater and painting, to convey the viewer's attention to the principal action or recapitulate its significance. One might argue that Christ, pointing to Matthew, is in that moment creating him as his disciple, much as God created Adam. But in Michelangelo's fresco the gesture is passive: it pertains to Adam, the man who is created, and not to God, the creator. Thus, in Caravaggio's work, the gesture has nothing to do with the significance of creation; it is only an "erudite quotation" of Michelangelo.

Countless artists have referred, with varying degrees of obviousness, to Michelangelo's celebrated gesture, and yet, until the second half of the twentieth century, such quotations would have been recognized for the most part only by the well educated. The motif of the two touching index fingers was not popularized until the 1950s, when the Swiss publishing house Skira featured

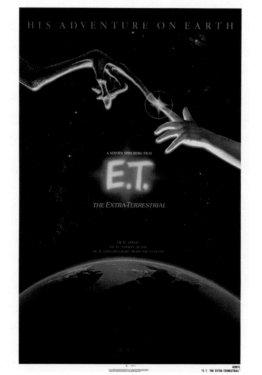

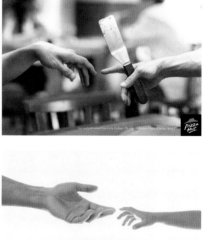

Poster for the film *E.T. the Extraterrestrial*, 1982

Pizza Hut's "Get ready for something truly Italian" ad by Ogilvy & Mather Kuala Lumpur, 2003

Nokia identity and tagline, 1997

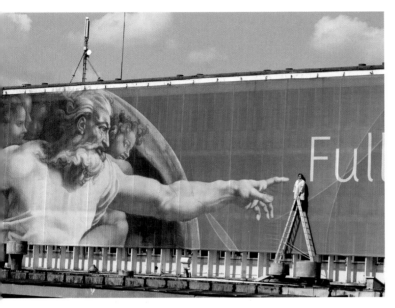

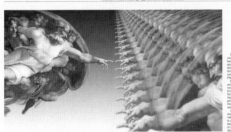

Cezary Bodzianowski
Onto, Lodz, 2009
Performance/film/photo

Illustration by Ji Lee
for Jaron Lanier's
op-ed on artificial
intelligence, *New York
Times*, August 9, 2010

it in a celebrated color plate, destined to have great visual impact, in a series of illustrated books on the Italian Renaissance titled *Painting, Colour, History.*

The touching hands, a detail removed from its context, have since become a sort of logo for the entire Sistine ceiling and for the Italian Renaissance. Many artists, including the Italians Mario Schifano and Tano Festa, began to produce irreverent versions with a Neo-Dada or Pop spin. "Is the American Pop artist open-minded when he declares a Coca-Cola bottle or an advertising poster to be a status symbol of his culture?" asked Festa. "I am sorry for the Americans who have so little history behind them, but for an Italian artist, a Roman and moreover someone who has lived a few steps from the Vatican walls, the Sistine Chapel is what is popular, the true *Made in Italy* brand."

Through gadgets, postcards, and kitschy low-cost replicas, the hands of Adam and God have ultimately become so much a part of the visual imagination the world over that Nokia chose it as the screensaver for its mobile phones: two hands reaching toward each other beneath the slogan "Connecting people." Though far from a faithful copy of the image on the Sistine ceiling, the hands still manage to refer subliminally to Michelangelo's art, communicating the message of a new humanity connected by jolts of the creator's energy. In 1982 Steven Spielberg employed the same gesture to represent human-alien contact in his film *E.T. the Extraterrestrial.* The reference to the Sistine Chapel did not pass unnoticed, to the point where many saw a parallel between Jesus and E.T.

Having become a sign in shorthand, this fragment of the image is now free to generate autonomous meanings (or in marketing terms, new messages). Today, having shrugged off the religious content that is probably ignored by most, this visual synecdoche—this part representing the whole, this detail that taken alone functions as an icon—may be profaned by advertising or sanctified by the culture industry because it has come to be perceived as a universal symbol of the story of humanity.

SISTINE MADONNA
Raphael

1512–13 Oil on canvas, 265 × 196 cm
— Gemäldegalerie Alte Meister, Staatliche Kunstsammlungen, Dresden

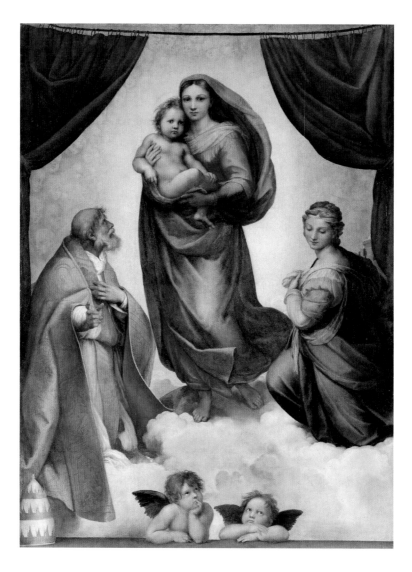

There is nothing banal in his work.

..

Eugène Delacroix

Sometimes an image ascends to the role of icon just because of a single small detail. This is, for example, what happened with *The Thinker* by Auguste Rodin or the *Sistine Madonna* by Raphael (1483–1520). In the first case, the French sculptor was responsible for isolating from the Gates of Hell the figure of a man immersed in thought. In the second, however, it was viewers who, over the centuries, directed their attention to the angels at the bottom of the composition and transformed them into the scene's protagonists.

Characterized by a particularly realistic and knowing countenance, the two winged putti seem to distance themselves from the mystical atmosphere that permeates the rest of the painting, manifesting a combination of boredom and perplexity—human expressions in stark contrast with the traditional representations of sacred and supernatural angelic figures. Raphael arrived at this brilliant stroke by embracing a new Renaissance iconography, already tested by Donatello and Andrea Mantegna, that merged pagan putti and Christian angels, adolescents and saints, classical myth and Catholic religion.

Julius II commissioned the work in 1512 for the Benedictine monastery of Piacenza's Church of San Sisto, where relics of the two saints were originally kept. The pope intended the painting both as a gesture of recognition for the city, which had supported his troops against the French, and as an homage to the basilica on the occasion of its reconsecration and dedication to the patron saint of the della Rovere family (of which he was a member). Created during Raphael's mature period and immediately recognized by Giorgio Vasari as a masterpiece, the *Sistine Madonna* revolutionizes many of the schemes previously employed for altarpieces. The curtains opening to the sides in tabernacle style reveal an unexpected and theatrical apparition against a misty backdrop of barely perceptible angelic faces; both the Madonna and the Christ Child have a grave air, halfway between reproach and concern. Saint Sixtus, wearing a cope with oak leaves and acorns—the heraldic device of the della Rovere family—could be a portrait of Julius II, and he points out toward the viewer/sinner to be redeemed. Saint Barbara, genuflecting in adoration, is distracted by the two aforementioned angels propped up on the balustrade below, who follow the events with emotional

The Fiorucci "Angels" logo designed by Italo Lupi, 1971. © Edwin Co. Ltd.

The Art of Prevention, a collection of postcards designed by Cliccaquì for LILA (Italian League for the Fight against AIDS), 2003

Cover of the Christmas 1872 issue of *The Graphic*, the influential British illustrated newspaper

detachment. The four-sided composition, in which no one figure makes eye contact with another, creates a tension that ensnares all who observe the painting. And yet, with the exception of the replacement of its frame in the Baroque era, the *Sistine Madonna* spent the first two centuries of its existence in relative isolation until the arrival in Italy of Frederick Augustus III of Saxony, king of Poland, in the autumn of 1754.

More interested in art than in the events that racked his reign, Frederick Augustus III was looking to acquire a Raphael for his collection in Dresden. Running into a work of such beauty in such a remote location came both as a surprise and an opportunity, with the sovereign offering 25,000 scudi for the painting—an exorbitant sum for the time, and one that the papacy promptly accepted,

replacing the original in the church with a copy.

The arrival of the *Sistine Madonna* at Dresden's Gemäldegalerie Alte Meister was an event of such magnitude that it ushered in a change in taste. According to the German scholar Andreas Henning, Correggio was the Renaissance artist most popular with the public in eighteenth-century Germany, but the following generation venerated the figure of Raphael, along with implied attributes of a not strictly aesthetic nature. Raphael's moral qualities, already vaunted by Vasari, combined with his ability to interpret religious subjects in a distinctively serene manner, did not escape the notice of Romantic authors such as Wilhelm Heinrich Wackenroder, Ludwig Tieck, and Friedrich Schlegel, and even more so the Nazarene painters, who viewed Raphael as an artist

Wilhelm Barth
*Boudoir of the Grand Duchess
Alexandra Fyodorovna in
the Aničkov Palace of Saint
Petersburg*, after 1823
Gouache, 75 × 54 cm
Prussian Palaces and Gardens
Foundation, Berlin-Brandenburg

appointed directly by God and an absolute point of reference for their art. The brothers Johannes and Franz Riepenhausen, engravers who had spent a great deal of time in Rome, were among the first inspired by the humanity of the *Sistine Madonna* angels, reproducing them as an isolated motif on stationery and cards celebrating saints' days. Even the Grand Duchess Alexandra Fyodorovna (born Charlotte of Prussia), wife of Tsar Nicholas I, had a reproduction of the two putti in her boudoir in Saint Petersburg, as deduced from a watercolor by Wilhelm Barth.

"Raphael-mania," particularly for the *Sistine Madonna*, spread through Russia and Prussia (whose dynasties were closely connected by marriage), to the point where reproductions of the painting decorated even the homes of Tolstoy and Dostoevsky. Its temporary theft and removal to Moscow during World War II, after the Red Army found it in a cave where the Nazis had hidden all the masterpieces from Dresden, served only to augment its mythical status. During its ten-year sojourn in the Soviet Union, the painting was publicly exhibited only once, at the Pushkin Museum in 1955, shortly before its return to Germany. In 2010 Bernhard Maaz, director of the Gemäldegalerie, was able to experience firsthand the work's impact when, on the occasion of a visit to the Russian capital, he met elderly visitors who still recalled their experience of seeing the painting in 1955 "almost as a miracle."

Although the "cutout" of the two cherubs may seem a consequence of modern merchandising, their solo career has been documented since the nineteenth century. It has become so well established that on the five hundredth anniversary of the creation of the *Sistine Madonna*, the museum in Dresden decided to devote a section of an exhibition to the influence of the two figures; the display included popular tributes and reinterpretations from around the world, from reproductions on embroidered tablecloths or cushions to deodorant ads. It's a demonstration of how the image of the angel/child has, in itself, an evocative power that has transcended, over time, the physical and spiritual boundaries of the Church.

LAS MENINAS
Diego Velázquez

1656 Oil on canvas, 318 × 276 cm — Museo Nacional del Prado, Madrid

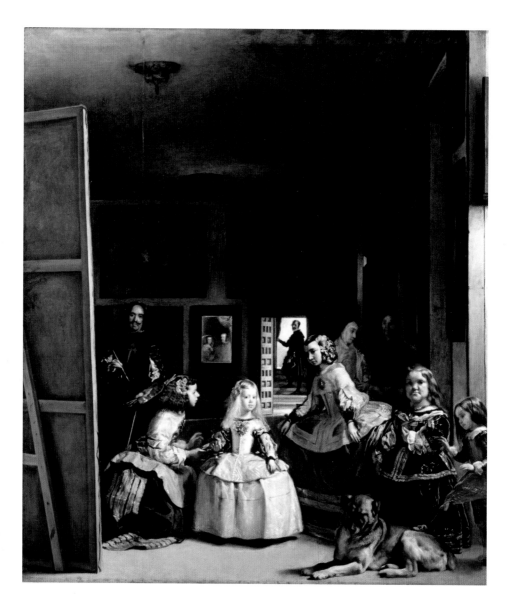

**Velázquez is an indication
of Spain's scale,
at a time when the balance
was rising and its dishes
laden with the wealth
of the golden age.**

Ramón Gómez de la Serna

When the Neapolitan painter Luca Giordano visited Madrid in 1692 at the invitation of Charles II, he was so thunderstruck by the massive *Las Meninas* that he reportedly exclaimed, "This is the theology of painting!"

In the inventories of the Madrid court, the painting by Diego Velázquez (1599–1660) was initially known as *Family Portrait*. King Philip IV first installed it in his private apartments on the ground floor of the Alcázar palace, where it survived a fire in 1734. In 1819 it was hung in the newly opened Museo Real de Pinturas (today the Museo Nacional del Prado), and it was one of the museum's directors, Federico de Madrazo, who published it in an 1843 catalogue under the title *Las Meninas*, a term of Portuguese origin that was used to designate the maids of honor at Spanish court.

Velázquez was fifty-seven years old and successful when he painted *Las Meninas* (he would die four years later). He was also well regarded in Rome, where he had made two journeys, and where he was deemed on a par with the greatest artists of his era. With *Las Meninas* he decided to challenge himself, bringing together technical virtuosity and intellectual acuity, sensory and cerebral

pleasures, to create a work that still fascinates experts and general audiences alike. The first thing worth noting is the rapid brushstrokes employed to create fluid figures, the contours of which are not clearly defined. They render the scene dynamic, as if capturing a fleeting moment, with the objective appearance of things transformed into emotion, memory, and atmosphere. Next, one sees the intellectual orchestration of an incredible play of elements that includes the viewer in the painting. In a mirror in the background, Velázquez paints reflections of the faces of Queen Mariana of Austria and King Philip IV, offering viewers the illusion that the artist is in reality working on a portrait of the royal couple. It is somewhat the same idea that Jan van Eyck had with his *Arnolfini Portrait* (1434), a painting Velázquez knew well—prior to its acquisition in 1842 by London's National Gallery, *The Arnolfini Portrait* was in fact part of the Spanish royal collections, where it remained until the Napoleonic Wars. But Velázquez went beyond this celebrated example, implying that the two sovereigns reflected in the mirror are actually standing behind the viewer. In other words, he places us right at the center of

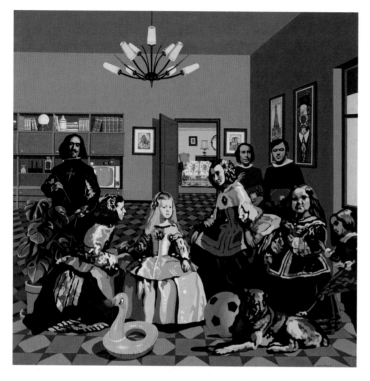

Equipo Crónica
La salita, 1970
Acrylic on canvas,
200 × 200 cm
Museu Fundación Juan
March, Palma de Mallorca

Ad for the Spanish
department store El
Corte Inglés, photographed
by Paco Navarro, 2009

Pablo Picasso
*Las Meninas (after
Velázquez)*, 1957
Oil on canvas, 194 × 260 cm
Museu Picasso, Barcelona

Melvin Sokolsky
*Las Meninas after Velázquez,
Isabella Albonico,
Nick and Melvin*, 1960
Harper's Bazaar

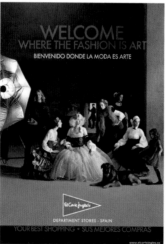

the action, between the rulers of Spain and the Infanta Margherita Teresa, her maids of honor, the dog, and the little dwarf who rests a foot on the dog's back. The timeframe is divided in two: we are simultaneously in the seventeenth century, in the royal palace, at the Habsburg court, and in the twenty-first century as visitors to the Prado. We are so integrated into the painting that our real lives disappear into the imagination. This is the high point of the Spanish Baroque. If there were a visual rendition of that famous statement by the seventeenth-century playwright Pedro Calderón de la Barca, "Life is a dream," it would be this painting. It is pure illusion. And what else is painting, if not illusion? Théophile Gautier intuited this perfectly when, facing the abyss of this "perspectival cube," he wondered, "But where is the painting?" The theme of *Las Meninas* is thus the very act of looking. There is an external world beyond the one shown on the canvas, and the artist challenges Art to rival Nature.

Despite its brilliant premise, for some two centuries the painting remained virtually unknown in Europe—like all Spanish art, due to the country's economic and political isolation. Around 1800 Francisco de Goya, fascinated by the example of Velázquez (who, like Goya, had been "painter to the king"), portrayed himself at the left margin of *The Family of Charles IV*, precisely as his predecessor had done in *Las Meninas*. It was a direct quotation that had the clear significance of a tribute, but it was the French Impressionists, particularly Édouard Manet and Pierre-Auguste Renoir, who rediscovered Velázquez's greatness and revealed it to the world. In 1865 Manet sent a letter from Madrid to his friend Henri Fantin-Latour: "I am so sorry you are not here. What joy you would have experienced to see Velázquez. He alone is worth the journey. He is the painters' painter."

Manet was inspired by *Las Meninas* for his own portrait of Velázquez in the studio (1860), and an echo of the Spaniard's illusionistic play of mirrors may be found

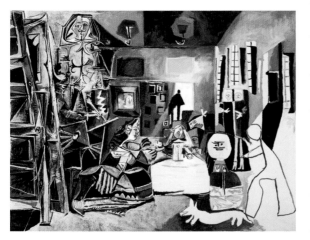

in *Bar at the Folies-Bergère* (1882). According to the critic Clement Greenberg, even Piet Mondrian picked up on the rhythmic structure of Velázquez's painting in the composition of *Broadway Boogie Woogie* (1942–43). In the twentieth century, this was precisely what challenged and fascinated other artists. Salvador Dalí made surreal interpretations through mirror games, while the American photographer Joel-Peter Witkin elicited a nightmarish, posthuman world that unmasks reality. It is a theme that also fascinated the British director Peter Greenaway, who projected onto the painting a complex play of images, like a text that is continually rewritten and reread. But the least intellectual and most immediate way of seeing *Las Meninas* is as the quintessence of *hispanidad*, the Spanish character, the emblem par excellence of Spanish art and its past imperial glory. This is the reason why, in the 1960s, during the dictatorship of Francisco Franco, the artistic collective Equipo Crónica profaned the painting, transforming it into a pop icon and a vehicle for political struggle. And its *hispanidad* is also the basis for nearly sixty paintings that Picasso made in 1957, obsessively studying the Velázquez work as a whole and in its details—not only to assert his artistic heritage, but also to inherit Velázquez's position as the greatest of all Spanish painters.

Today one can buy a piece of that Spanish imagination printed on handbags, hats, aprons, pendants, magnets, and gadgets of every kind. The painting's value as an icon can be measured precisely through the multiplicity of interpretations and meanings, whether popular, political, or epistemological, and with varying levels of accessibility.

GIRL WITH A PEARL EARRING

Johannes Vermeer

ca. 1665 Oil on canvas, 44 × 39 cm — Mauritshuis, The Hague

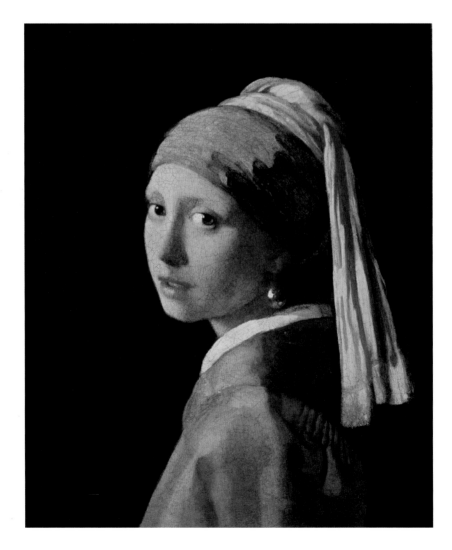

That indecipherability disconcerted me. What did Vermeer do to her to make her look at him like that? Unexpectedly the subject of the painting had changed from a portrait of a girl to one of the relationship between artist and model. There had to be a story behind that glance.

Tracy Chevalier

Cover of Tracy Chevalier's bestselling novel, 1999

Three hundred and thirty-four years. That is the time that elapsed between the creation of *Girl with a Pearl Earring* and its elevation to the status of global icon. It's an astonishingly long period, and one that highlights the difference between the objective value of a work of art and its perception, demonstrating yet again how the success of an image depends not only on its intrinsic qualities but also—and principally—on the interpretation of its viewers.

Bard of the seventeenth-century Flemish domestic atmosphere, the rather unprolific Johannes Vermeer (1632–1675) painted *Girl with a Pearl Earring* around 1665, though its precise date has never been established. Probably executed on his own initiative rather than on commission, the painting and its chronology were enveloped in almost total mystery until 1882, when the Dutch collector/genealogist Arnoldus Andries des Tombe purchased it for the paltry sum of two florins and thirty stuyvers at a minor auction organized by the Braam in Amsterdam. In 1903 des Tombe, who had no heirs, donated it to the Mauritshuis museum in The Hague, and it is there that scholars began giving it some attention. Due to the scant information available, their early hypotheses remained for the most part speculation but still served to increase general interest. Quickly and grandiosely dubbed the "*Mona Lisa* of the North," thanks to its subject's enigmatic expression, the young girl's portrait found an early supporter in the Austrian art historian Ludwig Goldscheider, who described it as "the most beautiful known Vermeer." The Dutch critic Jan Pieter Veth praised it even more emphatically, as a "consoling star that hovers in the great nighttime sky," while Danish artist Carl Bloch suggested that the painting brought to mind, more than Leonardo's *Mona Lisa*, Piero della Francesca's *Madonna of Senigallia* (ca. 1474)—a daring thesis but one in agreement with the thinking of art historian Roberto Longhi, who had always viewed the master from Arezzo as one of the precursors of Vermeer's pictorial style. During the twentieth century, the paucity of biographical information and the poor condition of the painting (the eyes and turban were victims of rough restoration work over the years, and the dark background

PURO COTONE SU TELA.

ZUCCHI

was originally green) prevented *Girl with a Pearl Earring* from occupying a prominent place in books and catalogues on Vermeer's work. Even Goldscheider, in a 1958 monograph, devoted only five lines to the painting, and it was not until 1999 that the American author Tracy Chevalier rescued it from relative oblivion.

In 1981 the nineteen-year-old Chevalier, still a student, visited the National Gallery of Art in Washington, DC, and bought a poster of the painting to hang in her room. In what might be considered a perfect reflection of the work's history, Chevalier—after having looked at the poster every day for sixteen years—had a sudden epiphany, wondering who the girl was, what was the reason for her glance, and why Vermeer had decided to paint her. Rejecting, like many others, André Malraux's theory that she was the artist's daughter, Chevalier began writing a novel in which she imagined the protagonist as a young housemaid in the Vermeer household caught between the artist's attentions, his wife's jealousy, and the pragmatism of a mother-in-law who saw in the girl's presence a source of disturbance but also of potential

inspiration (and income). Published in 1999, the novel sold two million copies, attracting the interest of director Peter Webber, who made a movie adaptation starring Scarlett Johansson and Colin Firth in the roles of the model and artist. The film adroitly captured the tension of the story and, with the help of Eduardo Serra's somber cinematography and Dien van Straalen's costumes, received nominations for three Academy Awards in 2004, catapulting *Girl with a Pearl Earring* into the public imagination. The meaning of the earring and turban, which have occupied scholars for decades (the former is an object of excessive value for someone of the girl's social class, the latter unusually exotic when compared to the rest of Vermeer's repertory), inspired theories identifying them as symbols of exchange, and thus of complicity, between the two actors in this domestic drama. This in turn aroused the creativity of advertising executives and fashion designers who did not hesitate to reprise the theme, thereby whetting the public's insatiable appetite for tales of unrequited love.

Today *Girl with a Pearl Earring* has officially displaced

Print ad for Faber-Castell
pencils by Ogilvy & Mather
Singapore, 2010

Ad campaign by the
Lorenzo Marini Group
Agency for Zucchi, an Italian
towel manufacturer, 2010

Erwin Blumenfeld
Model sporting natural face
after Vermeer *Head of a
Young Girl*
Vogue, August 1, 1945
Blumenfeld / *Vogue*
© Condé Nast

The Milkmaid (ca. 1660) as Vermeer's best-known work. If there are doubts in this regard, it suffices to consider the proliferation over the past ten years of Vermeer books and calendars with *Girl with a Pearl Earring* on their covers. Those who find depressing the idea of Hollywood diverting the course of culture and playing such a decisive role in the dissemination and consecration of a work of art might find comfort in the fate of the Mauritshuis. Since the film came out, the small museum has recorded an average of 250,000 visitors per year, reaping financial rewards sufficient to begin the restoration and expansion of its building and gaining a place in guidebooks throughout the world.

NAKED MAJA
CLOTHED MAJA
Francisco de Goya

1797–1800 Oil on canvas, 98 × 191 cm
1807–8 Oil on canvas, 95 × 190 cm
— Museo Nacional del Prado, Madrid

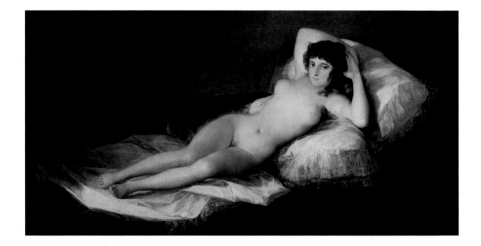

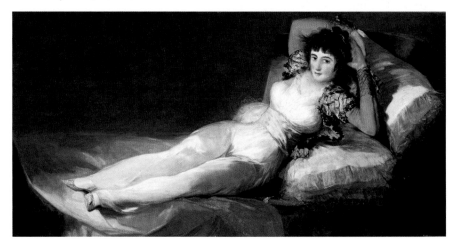

**Unlike the voluptuous women
of Boucher or Fragonard,
who are completely impersonal,
Goya's Maja is a realistic portrait.**

Alfonso Pérez Sánchez

Photograph by Herb Ritts for an advertorial,
January 1991

The popularity of the *Naked Maja* may be traced to 1901, when the painting was assigned an important spot in Madrid's Museo Nacional del Prado alongside its counterpart, the *Clothed Maja.* This was clearly an event for the extremely Catholic Spain, a place where painting, controlled by the church, had never addressed the theme of the female nude, with the exception of Velázquez's *Toilet of Venus* (1647–51). But in the history of art outside Spain, the female nude is a frequently recurring subject, and so the question is why this work by Francisco de Goya (1746–1828) became so globally famous.

A primary reason should be sought in the double image that gives viewers the impression that they are undressing the young woman as their eyes move from one painting to the other. Precisely as in the erotic imagination, the same woman is first presented clothed and then nude, arousing in the viewer a voyeuristic pleasure and the actual experience of desire. Beauty is yearned for first, and then possessed; on the one hand, plain desire, on the other its gratification. The observer, then, cannot help but feel party to the ancient seductive game of veiling and uncovering, seducing and conquering. (Many get embarrassed if caught lingering before the *Naked Maja* for too long.)

And then there is the life-size scale; the realistic face that challenges viewers, staring directly into our eyes; the impudent pose with arms behind the head, exposing the buxom bosom, without precedent in the history of supine Venuses in modern art and drawn directly from a well-known Hellenistic sculpture of the sleeping Ariadne; the hint of a smile; the voluptuousness of the silk cushions and the semidarkness of the room. Everything, in short, conspires to tell us that the Maja is a woman at our disposal. We feel free to undress her and at the same time feel that we are protagonists and voyeurs, living a somewhat cinematic experience.

However, the fame of this "image in motion" is also due to its being a brazen reworking of the classical theme of the sleeping Venus. In contrast with the numerous Venuses painted during the Renaissance, the Maja is no longer a traditional academic nude "clothed" in the garments of myth. She is instead a real woman, depicted

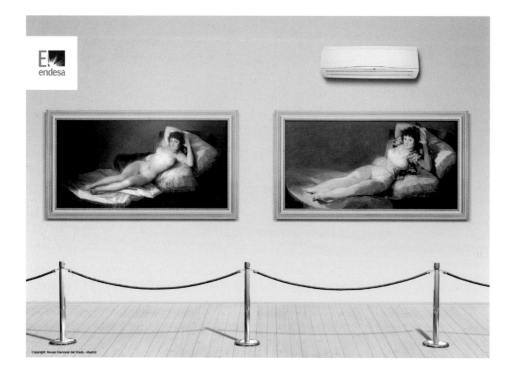

endesa

Copyright: Museo Nacional del Prado - Madrid

This 2008 ad for Endesa, Spain's largest utility company, inverts the sequence of Goya's *Majas*, adding an air conditioner above the *Clothed Maja* to imply that the temperature is cool enough for her to stay dressed.

with even her pubic hair visible—an utterly unusual detail in painting until that time.

The bold realism of the image is reinforced by the fact that we know the woman's name: Pepita Tudó, lover of Manuel Godoy, one of Queen María Luisa's favorite ministers. For a long time, however, people believed in another identity. According to a legend that made this nude even more licentious, the beautiful Maja was said to be the Duchess of Alba, a young noblewoman known for her loose morals. It seems that she, too, had been Godoy's lover, and had presented him a gift in the form of Velázquez's *Toilet of Venus*. The duchess, moreover, had hosted Goya at her estate in Sanlúcar de Barrameda, Andalusia, where she had withdrawn for a period of mourning following the death of her husband. That sojourn resulted in the rumor that Goya was her lover, too, and that the painter was so bewitched by her that he portrayed her in another painting pointing down with one hand to the words *Solo Goya* ("Only Goya"). In other words, an interwoven tale of lovers and nudes helped to arouse the public imagination.

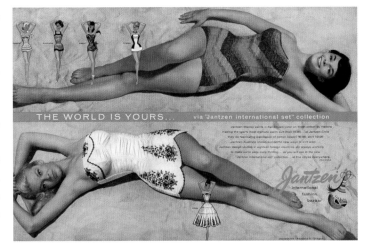

But there is more: the sinister factor of the Inquisition also comes into play. When Godoy fell into disgrace in 1808, his collection of paintings was transferred to the new king, Ferdinand VII. The *Naked Maja*, deemed obscene by the religious tribunal, was commandeered and hidden in the Depósito General de Secuestros until, following a royal order on April 13, 1836, the diptych was brought to the Real Academia de Bellas Artes de San Fernando in Madrid, where the *Naked Maja* was confined to a room with reserved access.

From Giorgione to Titian to Velázquez, critics and scholars have been able to speak of other female nudes as portrayals of Venus, thus skirting the fact that these were images intended for the erotic delectation of their owners. But in the case of the *Naked Maja* it is impossible to deny that this is a real person, and the mystery of her identity renders the image positively titillating. Whereas female nudes exhibited in museums typically arouse a response of self-censorship, with the public tending toward an intellectual interpretation, the conjoined effect of Goya's *Majas* legitimizes an erotic interpretation, even among the most cultivated of audiences.

Even today, when nude women are certainly no rarity, postcards of the *Naked Maja* are among the most popular items purchased and mailed by Prado visitors to every corner of the globe. This is precisely because it is not just any naked woman but a particular woman disrobed, a sort of sexual conquest. This might explain the puritanism of the directors of the American postal service in 1930, toward the end of the dictatorship of Miguel Primo de Rivera, when they refused to accept correspondence arriving from Spain if the *Naked Maja* was reproduced on the stamp.

Jantzen's "The world is yours"
ad, 1956

Laros of Bethlehem lingerie
ad, 1944

LIBERTY LEADING THE PEOPLE
Eugène Delacroix

1830 Oil on canvas, 260 × 325 cm — Musée du Louvre, Paris

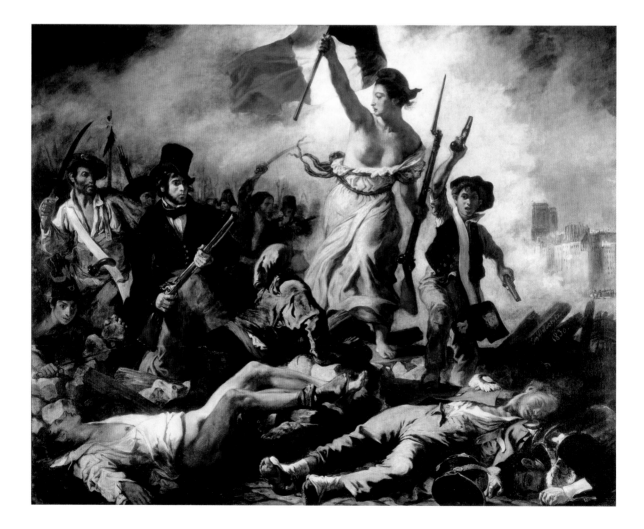

From time to time a work of art contrives to bring together and express all the ideas that mean most to the spirit of a particular time and give it its meaning. This is certainly the case with Delacroix's *Liberty Leading the People*, in which the clamor of a generation on the march becomes a joyous and unanimous hymn.

René Huyghe

The Statue of Liberty, designed by Frédéric Bartholdi and dedicated in 1886, was a gift to the United States from the people of France.

It would be perilous to ignore the importance of guilt as a force of change in history. It is the ultimate reason, to give one example, why Archbishop Diego de Landa spent the final years of his life rebuilding what little was left of Mayan culture after he tried to erase it. Great revolutions, like great innovations, often originate from the desire to correct a regrettable mistake.

In the history of art, the work that perhaps most unequivocally crystallizes the concept of guilt is *Liberty Leading the People* by Eugène Delacroix (1798–1863). The apocalyptic portrayal of the republic in the guise of Liberty—bare-breasted, a Phrygian cap atop her mane of brown hair, waving the flag of rebellion as she treads over corpses—in fact emerged from the imagination and brush of a man who by nature and habit was precisely the opposite. Eccentric and egocentric, Delacroix was sort of a wimp: a confirmed bachelor, alienated from the masses, fragile of constitution, timid (he stayed home while many, including his beloved Lord Byron, went to aid the Greek struggle for independence from the Turks), and completely devoted to his art. But there are historical moments when one must take sides, and proof of the degree to which Delacroix was aware, as an artist and social observer, that he was not rising to the occasion of his time lies in a letter addressed to his brother, a general, and dated October 28, 1830, right in the midst of the second French revolution: "I have started work on a modern subject, a scene on the barricades. I may not have fought for my country but at least I shall have painted for her."

René Huyghe, a member of the Académie Française and the author of a voluminous study on the artist's work, does not waver in this regard: "Delacroix's enthusiasm for the revolution undoubtedly entailed certain reservations. Profoundly aristocratic by nature, extremely bourgeois by education, he partook moderately of the unbridled excesses of the popular frenzies. Alexandre Dumas related that our painter saw with pleasure the tricolor flag flying anew, which had been associated with the pomp of the empire, but reacted with reticence and perhaps fear to the rage of the populace."

Detached correspondent or active participant, Delacroix

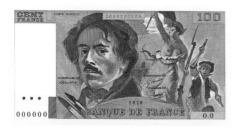

French 100-franc banknote depicting Eugène Delacroix and a fragment of *Liberty Leading the People*, 1993–99. Collection of Banque de France

Cover of the Coldplay album *Viva La Vida or Death and All His Friends*, 2008. Designed by Tappin Gofton

describes/interprets the hot summer of 1830, affirming his support for patriotic ideals and European liberalism as a fact of present-day life, captured live with an approach halfway between photographic reportage and commemoration. Similarly, aided by the lighting and composition, the improbable figure of the scarcely clad woman who leads the people moves imperceptibly from an idealized role to one of a real presence—and vice versa. The result is a mélange of references to the classical female figure and current events that makes the scene appear like something real but eternal. As Charles Baudelaire correctly observed, "Rarely have the opposing forces of classical examples and the discovery of the Romantics been seen to balance and foster each other in an indiscernible amalgam, here made complementary. The allegory favored by the former, the lyricism of action that enthralls the latter, merge here in an unexpected and audacious manner with the veracity of the realists, who will soon be engaged in the observation of contemporary life and the idea of 'modernity.'"

Partly live reporting and partly mise-en-scène, *Liberty Leading the People* shows the mass of people streaming out like a wave directly toward the viewer, following a diagonal trajectory along the lines favored by the Baroque. The figures who surround the heroine have long been the subject of study; they can be identified through their clothing as coming from different social classes, a deliberate indication of their equality before a higher power. Some have seen Delacroix himself in the man with the trumpet, a psychologically intriguing possibility but one that cannot be verified. Much attention has also been given to the hypothesis that the young boy at the right in some way inspired Victor Hugo to create the character Gavroche in *Les Misérables* (1862), a novel that concludes with the insurrection that led to the fall of the Bourbons and the advent of the constitutional monarchy of Louis Philippe d'Orléans.

Poster by Plinio Codongato
for FIAT, 1925

Cotton Joy's ad campaign
"PoweRevolution," 2008

Thus an episode that is realistic, rather than real, is transformed into an allegory of the sublime—or, to quote Walter Friedlaender, "is lifted from the realm of naturalism into the artist's characteristic sphere of grandiose fantasy."

The response that *Liberty Leading the People* encountered at its maiden presentation at the Salon of 1831 is quite well known. Acquired by the new government of Louis Philippe for the royal museum but immediately deemed too subversive, the painting was hidden away in storage until 1874, when it was exhibited at the Musée du Louvre. The display inflamed the spirit of the French, who experienced for the first time what was essentially a modern political painting, removed from antiquity and deeply immersed in contemporary life. This was to be confirmed through the idealistic and populist use of Delacroix's image over time, from the creation of the Statue of Liberty, conceived by Frédéric Bartholdi in 1886; to the commemorative stamp by Robert Ballagh celebrating Irish independence, issued in 1979; to the cover of the British band Coldplay's *Viva la Vida or Death and All His Friends* (2008), an album that focuses on absolute values such as life, death, love, and war; to ads from Telecom Italia, the Italian phone company, reminding consumers of the liberty, fraternity, and equality of its rates.

Beyond its political and social symbolism, Delacroix's work is also the first example of how reality can be faithfully described even when it is based on a moderate dose of fiction—particularly if this reality corresponds to a larger aspiration.

THE GREAT WAVE
Katsushika Hokusai

ca. 1830–32 Woodcut print, 26 × 38 cm — Bibliothèque Nationale de France, Paris

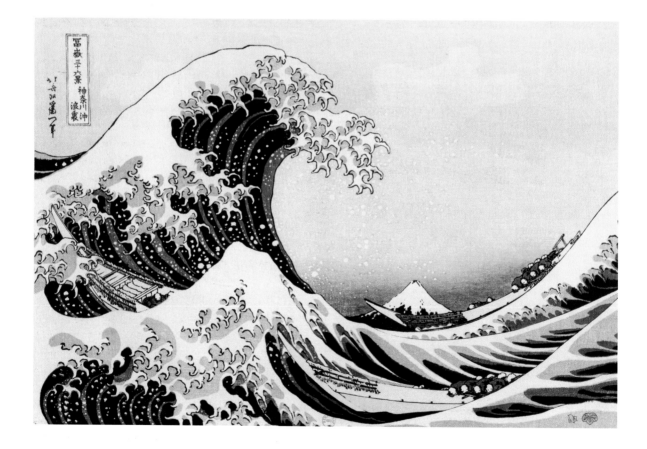

**From around the age of six,
I had the habit of sketching from life.
I became an artist, and from fifty on
began producing works that won
some reputation, but nothing I did
before the age of seventy was worthy
of attention. At seventy-three, I began
to grasp the structures of birds
and beasts, insects and fish, and of
the way plants grow. If I go on trying,
I will surely understand them still better
by the time I am eighty-six, so that
by ninety I will have penetrated
to their essential nature. At one hundred,
I may well have a positively divine
understanding of them, while at
one hundred and thirty, forty, or more
I will have reached the stage where
every dot and every stroke I paint
will be alive.**

Katsushika Hokusai

Despite being only a small and fragile piece of paper, *The Great Wave* has become a world-renowned symbol of Japanese art. Part of the celebrated series *Thirty-Six Views of Mount Fuji*, it was created by the Japanese painter and printmaker Katsushika Hokusai (1760–1849) around the age of seventy.

Following a life of ongoing poverty and instability during which he always stayed dedicated to his art, Hokusai, within some ten years of his death, had become a legend in the West—particularly in France, where he played a fundamental role in the success of the phenomenon of Japonisme, and where he had fervent admirers among the Impressionists, including Manet, Degas, Van Gogh, Gauguin, Toulouse-Lautrec, and Seurat. It was the same moment when the myth of *la vie bohème* was taking root, an additional fact that propelled the enormous fascination with Hokusai's work and the perception of him as a *kijin*, or eccentric.

Of humble and obscure origin, Hokusai was a figure wrapped in the aura of legend, enhanced by performances such as one in which he drew a gigantic bust of Daruma, the patriarch of Zen Buddhism, using a broom of reeds dipped in ink. A tireless producer of every genre of image, from female beauties to manuals for painters, from landscapes and animals to scenes of daily life, he used more than a hundred signatures on his works but announced only five official names for his art-making activities and related seals, representing his six major stylistic periods after receiving the initial name of Shunro from his teacher.

The print of *The Great Wave*, inscribed *Hokusai aratame Iitsu hitsu* ("from the brush of Hokusai, who changed his name to Iitsu") was immediately received as innovative for its new approach to landscape. Traditionally relegated to the background, landscape here emerged as an autonomous genre of equal importance to figural representations. In Hokusai's work, nature reflected psychological characteristics and was placed in direct relationship with the supernatural. The opposition between darkness and light, between the power of nature and human forces, between sea and sky, seems to be composed graphically in the symbol of yin and yang.

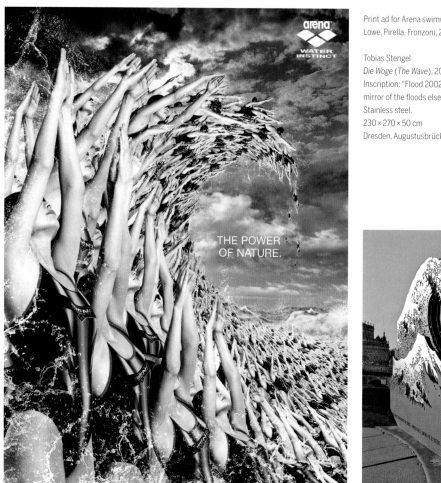

Print ad for Arena swimwear by
Lowe, Pirella, Fronzoni, 2008

Tobias Stengel
Die Woge (*The Wave*), 2006
Inscription: "Flood 2002—
mirror of the floods elsewhere"
Stainless steel,
230 × 270 × 50 cm
Dresden, Augustusbrücke

The wave breaking free from the sea enters the space of the sky, becoming a unique movement for which Fuji, the highest peak in Japan, acts as an immobile fulcrum. Mount Fuji, furthermore, is the first thing upon which the sun, the greatest divinity in the Shinto pantheon, rests on each new morning. The three boats and their passengers, tossed by the waves, seem first on the point of succumbing to the elements, then capable of moving with them, becoming one with the alternating rhythm, while all the primary elements—divine, human, terrestrial (*ten, jin, chi*)—have equal weight in the eternal flow of becoming.

The print thus seems like a sort of poem dedicated to the divine element that pervades the incessant breath of creation. Art historian Gian Carlo Calza has written that it conveys "his concept of the forces of nature. In Hokusai's view these forces are not there to be dominated and exploited—as Western culture has perhaps tended all too frequently to do, with possibly dire consequences—but to be loved and accommodated according to the rhythm of their power, so as to be carried along rather than overwhelmed."

It is significant that in his introduction to *Hokusai gashiki* (*Hokusai's Drawing Method*) of 1891—one of the many prestigious how-to manuals that he published for beginning painters—Hokusai writes: "Painting is a micro-

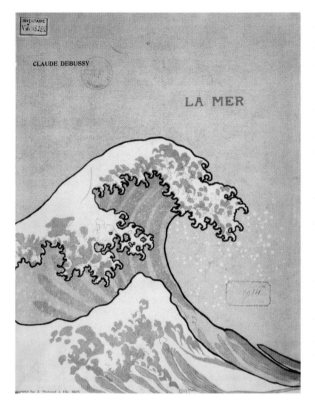

Hokusai's *Great Wave*
on the cover of Claude
Debussy's musical score
La Mer, 1905

Illustration by
André Rösler, titled
*Chances 2009: Even a Recession
Offers Chances*, published in
Frankfurter Allgemeine Zeitung,
December 17, 2008

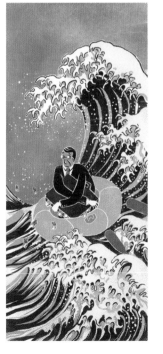

cosm. Those who would like to follow this Path must fill their hearts with the spirit of the four seasons and master the process of creation." His late works, above all, reinforce a worldview based on the idea that all things, including inanimate objects, possess a soul or a spirit. "By ninety," he writes, "I hope to be able to renew my pictorial style, and by one hundred, to revolutionize this path." But he died in 1849 at the age of eighty-nine, having already declared himself an "art-crazy old man."

Hokusai's influence on the Western avant-garde was immense. Edgar Degas wrote that Hokusai "is not just one artist among others in the Floating World, he is an island, a continent, a whole world in himself." In a sculpture by Camille Claudel entitled *The Wave* (ca. 1897–1903), now at the Musée Rodin in Paris, the three boats from *The Great Wave* become nymphs holding hands beneath a looming, frothy wave. Claude Debussy, who maintained that Hokusai's print was the inspiration for his symphony *La Mer*, chose the image for the cover of his 1905 score, and Van Gogh referred to the sinuous movement of the water in the clouds of *The Starry Night* (1889).

It is curious to see that immediately after Hokusai's death, the West interpreted *The Great Wave* in its original poetic and animist spirit, whereas contemporary Japan, that great disseminator and consumer of trendy products, began to use the image on phone books, computers, and advertising for cars and washing machines—a practice that eventually spread to the West. *The Great Wave* has since been widely appropriated for its association with the idea of energy, movement, and modernity, giving added value to products connoting high-tech quality and seductive design.

LUNCHEON ON THE GRASS
Édouard Manet

1863 Oil on canvas, 208 × 265 cm — Musée d'Orsay, Paris

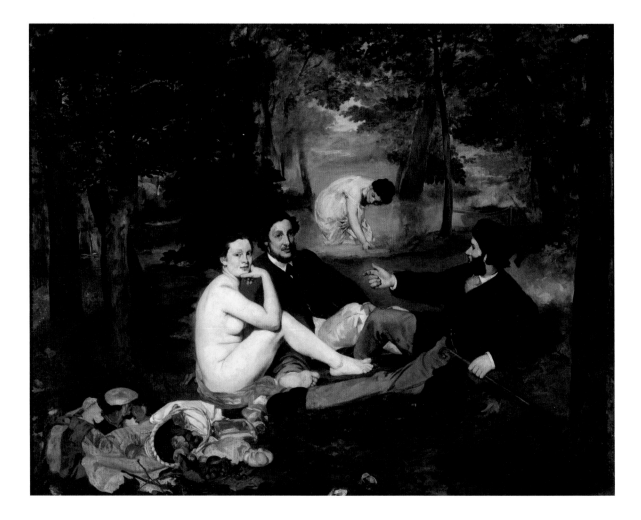

A woman without the slightest covering between two clothed men! That has never been seen. And this belief is a gross error, for in the Louvre there are more than fifty paintings in which are found mixes of persons clothed and nude. But no one goes to the Louvre to be scandalized.

Émile Zola

Cover of the third installment
in the American comic book series
Army@Love: The Art of War by Rick Veitch.
© Rick Veitch. Used with permission
of DC Comics

One of the paradoxical circumstances that can lead to a work of art's success is its censorship. Among the most striking examples of this well-proven fact is *Luncheon on the Grass*, a painting whose innocuous, bucolic appearance conceals a story of rejection, intrigue, and scandal that would inspire jealousy in all of the artists who have made a franchise of provocation. It was an astonishing outcome for many, including artist Édouard Manet (1832–1883), who certainly never expected his harmonious composition—undertaken with the single goal of producing an updated, bourgeois version of a subject introduced centuries earlier by Giorgione, in *The Tempest*, and Titian, in *The Pastoral Concert*—to stir up a fuss sufficient to capture the attention of eminent individuals such as Émile Zola, Marcel Proust, and Emperor Napoléon III.

Luncheon on the Grass's struggle began in March 1863, when the French Ministry of Culture declared that every artist would be allowed to submit a maximum of three works to the Paris Salon. The unpopularity of this decision predictably unleashed a chorus of protest. Manet, Gustave Doré, and other artists signed a petition demanding the decree be nullified but, despite support from influential press such as *Le Courrier Artistique*, the ministry was inflexible. By no means discouraged, Manet challenged the authorities by submitting three lithographs and three paintings: *Luncheon on the Grass* (originally entitled *The Bath*), *Mademoiselle V . . . in the Costume of an Espada*, and *Young Man in the Costume of a Majo*. The jury remained immovable and went on to reject some 2,800 of the 5,000 works submitted, including those of Manet. If the ministry's original edict had created animosity, this latter restriction generated a wave of dissent that not even the emperor could ignore. Napoléon III attended a preview of the exhibition, and after establishing, from the heights of his (in)competence, that the merit of the included and excluded artworks was more or less the same, he decided to play it safe, inviting the rejected artists to display their work in another wing of the Palais de l'Industrie. He also changed the Salon from a biennial to an annual event, in hopes that more exhibiting opportunities might fend off a recurrence of similar

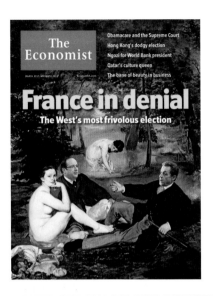

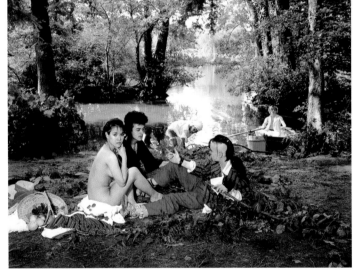

During the 2012 French election campaign, the cover of an issue of *The Economist* showed François Hollande and Nicolas Sarkozy reclining on the grass in Manet's painting.

Cover of the Bow Wow Wow album *See Jungle! See Jungle! Go Join Your Gang, Yeah! City All Over, Go Ape Crazy!*, 1981. Photographed by Andy Earl.

incidents in the future.

When the Salon des Refusés opened on May 15, two weeks after the opening of the official exhibition, the climate was so charged with expectation and polemic that critics and the public fell victim to reactions of inverse proportion: the former disdained the event (Louis Leroy, who later invented the term *Impressionism*, bitterly dismissed it as the "Salon of Pariahs"), while the latter turned out in droves. The exhibition's success did not escape the emperor, who brought the affair to a close a month later with a final demagogic gesture, removing Count Walewski from the helm of the Ministry of Culture.

Manet, meanwhile, had to come to terms with conflicting responses from the critics who had deigned to visit the exhibition. Didier de Monchaux accused Manet of using brushes as if they were implements for cleaning the floor; Louis Étienne called the subject reprehensible, while Édouard de Lockroy praised the artist's intentions (although with some perplexity), presciently adding that "Manet will triumph one day . . . and we shall be the first to applaud his success."

In hindsight, all three of these illustrious voices were correct. Though he was endowed with indisputable talent, painting details did not come easily to Manet—and yet it was precisely that stylistic simplicity, coupled with an unusually large format, that immediately distinguished the painting. As for the subject, the idea to depict unclothed women in poses borrowed from sixteenth-century models (Manet claimed as inspiration Raphael's *Judgment of Paris*, via an engraving made by Marcantonio Raimondi), transported into a modern context (the wooded banks of the river at Argenteuil, crowded with gypsies and prostitutes), stirred a scandal that became much more heated than the controversy over the dictate of the Ministry of Culture. The fact that the central nude was a hybrid of Manet's model (Victorine Meurent) and his wife (Camille), and that the two men were his brother

Jeff Wall
Tattoos and Shadows, 2000
Photograph, dye destruction
print transparency in
aluminum light box,
196 × 255 cm

and a sculptor friend (Ferdinand Leenhoff, his future brother-in-law), stripped the figures of any allegorical modesty and inspired a prudery that Manet himself shrewdly exploited when he nicknamed the painting "The Wife-Swapping Party."

Pablo Picasso was among the first twentieth-century artists to take up the theme of *Luncheon on the Grass* in 1962, while Malcolm McLaren and Vivienne Westwood, always on the hunt for provocative imagery, invited British artist Andy Earl to reconstruct the scene for the cover of the 1981 album *See Jungle! See Jungle! Go Join Your Gang, Yeah! City All Over, Go Ape Crazy!* by the New Wave band Bow Wow Wow. In 1999 Mario Sorrenti created a campaign for Yves Saint Laurent that inverted the roles, showing a clothed Kate Moss in the company of two naked men. Canadian artist Jeff Wall, who had already established a dialogue with Manet in his *Picture for Women* (1979), elegantly cited elements of the work in

Tattoos and Shadows (2000). American comic-book artist Rick Veitch used the image for the cover of the third installment in the series *Army@Love: The Art of War* (2008), and in the spring of 2012, *The Economist* used it to suggest excessive lightheartedness on the part of the French vis-à-vis the upcoming presidential election.

These examples—and there are plenty more, ranging from advertising to fashion to cinema—suffice to indicate why *Luncheon on the Grass* has become such a success. Obsessed with the idea of respecting the past while living in the present, Manet accomplished what Charles Baudelaire had championed for years, namely the pictorial representation of modern life. An innovative concept at the time, that represented a break with tradition that left an indelible mark on the history of art.

THE THINKER
Auguste Rodin

Modeled 1880–81, enlarged 1902–4, cast 1919 by Alexis Rudier Bronze, 200 × 130 × 140 cm
— Rodin Museum, Philadelphia, bequest of Jules E. Mastbaum, 1929

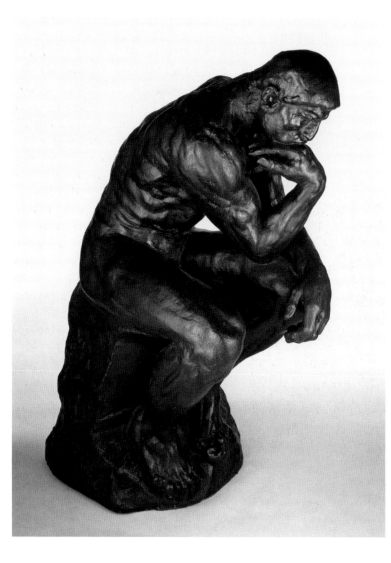

He brings to his sculpture a wayward inspiration, a grandiose lyrical impetus, and these would be well and truly modern had Michelangelo and Donatello not had them, in virtually identical forms, four hundred years ago, and if Rodin himself had used them to put life into a reality conceived in entirely new fashion.

..................................

Umberto Boccioni

Albrecht Dürer
Melancolia, 1514
Engraving, 24 × 19 cm
Kupferstichkabinett,
Staatliche Museen zu Berlin

An authentic giant of sculpture as well as a point of reference for its passage from nineteenth-century neoclassicism to twentieth-century modernism, Auguste Rodin (1840–1917) is a paradigmatic example of how an artist can be innovative without turning against the past. The completion of his stylistic development around 1870, updating the Hellenic Renaissance tradition with a respectfully contemporary approach, drew criticism from many of his colleagues, and Rodin did not begin to receive recognition until the end of the nineteenth century. The imposing *Thinker* (1880–81) is the masterpiece that gave him immortality, though iconographically it is anything but a new image and descends directly from the great Renaissance masters.

The long history of *The Thinker* began in 1880, when Rodin was asked by the city of Paris to create the doors for the future Musée des Arts Décoratifs. The invitation, which came from Edmond Turquet, the undersecretary of fine arts, was not without implications. French sculptors at that time had a lukewarm relationship with institutions, which they considered barely competent in art-related matters and production costs. The idea of undertaking a work of such commitment and scale for an inadequate fee (the overall budget was eight thousand francs, when a sculptural bust would typically command around two thousand), and moreover for a nonexistent museum, held no attraction for the Parisian art community. Technically skilled, trained in the decorative tradition, and still relatively unknown, Rodin was identified as the perfect candidate for the project, and in fact he enthusiastically welcomed the commission, proposing a bronze bas-relief inspired by Dante and Michelangelo, two mythical figures of his youth.

Christened *The Gates of Hell* in homage to the first canto of Dante's *Divine Comedy*, the portal consisted of three sections. From the start, the apex figure stood out: a seated male nude with his chin resting on his fist. The pensive pose harked back to the art of the sixteenth century, especially Raphael's portrait of Michelangelo as the Greek philosopher Heraclitus, part of the *School of Athens* fresco in the Vatican (ca. 1510–12); the tomb of Lorenzo de' Medici sculpted by Michelangelo (1519–33); Albrecht

Quiet! by the illustrator Marcelo Rampazzo, 2011

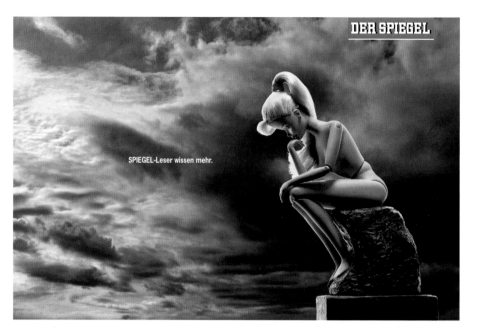

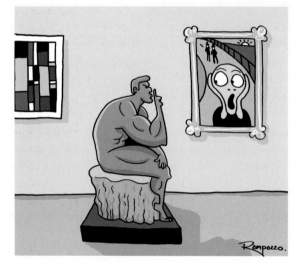

Dürer's celebrated engraving *Melancolia* (1514); and Dürer's drawing for the *Monument to the Vanquished Peasants* (1525). Many were under the impression that *The Thinker* was actually Dante (which explains why it was originally known as *The Poet*), but it could also be seen as a self-portrait of the artist—a projection of identity that occurs rather frequently in the work of Rodin. As the British art historian Catherine Lampert has observed, he made the figure stand out "as an alter-ego presiding imaginatively over the construction."

When plans for the construction of the Musée des Arts Décoratifs were presented with no specific deadline, Rodin found himself in the unfortunate position of being stuck with a monumental and virtually unsellable work to which he had dedicated considerable time and energy. Discouraged but not defeated, he began to extrapolate some of the portal's elements and, with help from Henri Lebossé, enlarged the dimensions. It was a rather unusual process; many successful artists replicated their sculptures on a reduced scale for commercial reasons, but the opposite rarely occurred. When the scholar François Thiébault-Sisson visited Rodin's studio in 1903 and saw the first large-scale bronze cast for *The Thinker*, he was so struck that he immediately deemed

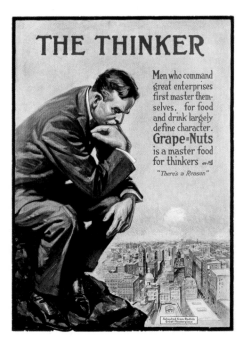

Grape Nuts cereal ad in an issue of *Life* magazine, 1918

Print ad for the footwear brand a.testoni, concept and photo by Roger Corona, 1997

it the artist's most important work—a sign of faith that convinced Rodin to exhibit it at the 1904 Salon.

Thanks to its massive size and central position in the exhibition, *The Thinker* soon became the focal point of the Salon, arousing a positive response even from Rodin's enemies. Critic Gabriel Mourey called it "a man for all seasons," while Gustave Geffroy, a journalist and art expert, circulated a petition to prevent the sculpture from being shipped off to America or Great Britain, where Rodin's work apparently was more appreciated. Geffroy's campaign, as well as a reshuffling in the government, led to a decision in June of that year to place *The Thinker* in front of the Panthéon, but a crowd's acts of vandalism in January 1905 contributed both to postpone its official dedication and further increase its fame.

Rodin, meanwhile, had already begun to make copies for exhibitions in Leipzig and at the New Gallery in London. A turning point came in 1906, when *The Thinker* was finally restored and inaugurated with great pomp in Paris, giving Rodin the honor of seeing one of his works in the center of the city for the first time.

A study of contrasting and coexisting concepts—physicality and intellect, torment and profundity, authority and fragility—*The Thinker* was immediately understood as a monument to both the limitations and the power of humanity. Universities, museums, and cemeteries from Venice and Tel Aviv to New York and Mexico City immediately grasped its significance and potential. The work's endemic reproduction ended up influencing popular culture, where tributes have ranged from celebration to parody. Its patent majesty functions as a double-edged sword, and it would not be hazardous to say that the sculpture, for all its solemnity, may still be viewed with a certain humor. Advertising has been quick to recognize this, for instance selling bathroom products by exploiting *The Thinker*'s seated position.

But the transformation of an artwork into an icon is often due to a simplicity factor. Today there are at least twenty casts of *The Thinker* in all corners of the globe, including the one erected on Rodin's tomb in the town of Meudon, sealing the enduring association between the artist and his creation.

SUNFLOWERS
Vincent van Gogh

1888 Oil on canvas, 92 × 73 cm
— Neue Pinakothek, Munich, Bayerische Staatsgemaeldesammlungen

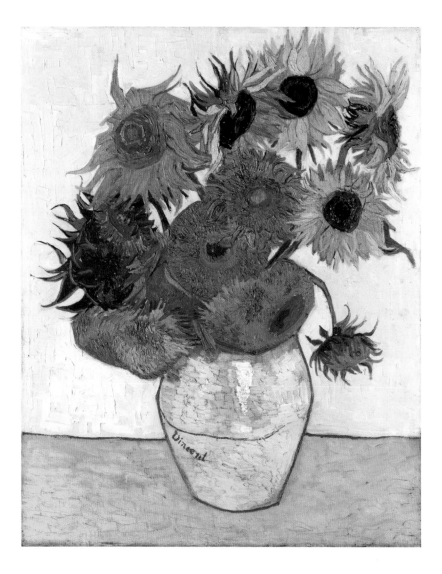

**It's a type of painting that changes
its aspect a little, which grows in richness
the more you look at it. Besides,
you know that Gauguin likes them
extraordinarily. He said to me
about them, among other things:
"that— . . . that's . . . the flower."
You know that Jeannin has the peony.
Quost has the hollyhock, but I have
the sunflower, in a way.**

Vincent van Gogh

The tormented Dutch painter Vincent van Gogh (1853–1890), who died at the age of thirty-seven, probably from a self-inflicted gunshot wound, spent most of his life amid struggle and difficulty. The worldwide glory and honor that eluded him in life came posthumously in the form of record auction prices for his paintings (over a hundred million dollars), scores of retrospectives at the most prestigious museums, and an unrivaled range of merchandise that includes postcards, posters, coffee mugs, and eyeglasses. Van Gogh is, in fact, a canonical example of the mad, misunderstood genius who faces the skepticism and indifference of those around him with the stoical conviction that he is right, and whose long-denied recognition arrives only after death.

While it would be simplistic to ascribe Van Gogh's fame exclusively to the private drama that marked his life, it would also be ingenuous to negate its impact. One who was well aware of this was his sister-in-law, Johanna van Gogh-Bonger. After the death of the artist and his brother, her husband Theo van Gogh, Van Gogh-Bonger found herself in sole possession of nine hundred paintings by the former as well as eight hundred letters exchanged by the brothers over the years. When she read the correspondence, she immediately realized she was sitting on a goldmine but wisely delayed publication until 1914. This gave her time to develop a careful marketing strategy, counting on the fact that the increasing interest in the artist's work would stimulate the public's curiosity about his personality.

Riding the wave of acceptance that Van Gogh's work had begun to receive two years prior to his death, from figures such as his Dutch colleague Joseph Jacob Isaacson and the French Symbolist Albert Aurier, Van Gogh-Bonger got in touch with various supporters—artists, art dealers, and collectors—and organized exhibitions in Brussels and Paris. Several museums negotiated the purchase of his paintings, including the Museum Folkwang in Essen, the Tate Gallery in London, the Stedelijk Museum in Amsterdam, and the Museum of Modern Art in New York. Further international fame arrived in 1928 with the appearance of the first catalogue raisonné, edited by Jacob Baart de la Faille.

The two series dedicated to the theme of sunflowers, which Van Gogh executed between 1887 and 1888

during sojourns in Arles and Paris, reflect a passion for nature and its chromatic potential, yet what is also shining through is a sense of serenity and veiled optimism quite rare in his work. According to the scholar Judith Bumpus, who in 1988 dedicated an entire book to Van Gogh's flowers, it is almost as if the artist were painting the blooms in gratitude for the happiness and peace they brought him.

Paul Gauguin greeted the first sunflowers, created in Paris in 1887 in the form of a sketch, with such admiration that Van Gogh was encouraged to make them the principal decorative motif in the yellow room his friend occupied in Arles that summer. In addition to their natural harmony and remarkable interpretation of color, the *Sunflowers* also demonstrated the influence of traditional Japanese flower prints—an aspect that did not escape the notice of Japanese billionaire Yasuo Goto nearly a century later, in 1987, when he purchased a version on auction at Christie's in London for the record sum of $40 million.

Van Gogh painted numerous versions of the *Sunflowers*. Two remained in the possession of his family before finding their current home at the Van Gogh Museum in Amsterdam; four ended up in private collections; and others may be found in public collections, including the Neue Pinakothek in Munich (the version seen here), the Kunstmuseum Bern, the Metropolitan Museum of Art in New York, the National Gallery in London, and the Philadelphia Museum of Art.

The attention paid to Van Gogh by fashion, cinema,

Ashish sunflower dress,
spring/summer 2012

WHEREVER YOU PAY, CULTURE IS NEVER FAR AWAY.

> THE NEW **FNAC MASTERCARD** DEBIT CARD.

Vincent V.
GRAPHISTE

From scratch to masterpiece. shutterst**o**ck

and advertising, with a special emphasis on the *Sunflowers,* is irrefutable proof that his vision has become an integral part of popular culture today. It should not come as a surprise that such a passionate life story would ignite the imagination of filmmakers, resulting in Vincente Minnelli's embarrassing *Lust for Life* (1956) as well as Jack Reilly's *Vincent's Final Moments* (2002). The floral motif has been the subject of suggestive interpretations that heighten the flowers' freshness, luminosity, or fragility, demonstrating that Van Gogh's greatness may lie above all in his capacity to transform the ordinary into the extraordinary.

Clearly undervalued during his lifetime and probably overvalued after his death, Van Gogh surely knew what he was doing when he said that the *Asteraceae* would be perennially associated with him. Today, in fact, it is impossible to see or reproduce sunflowers in any context without triggering a recollection of the Dutch master.

THE SCREAM
Edvard Munch

1893 Oil, tempera, and pastel on cardboard, 91 × 74 cm — National Gallery, Oslo

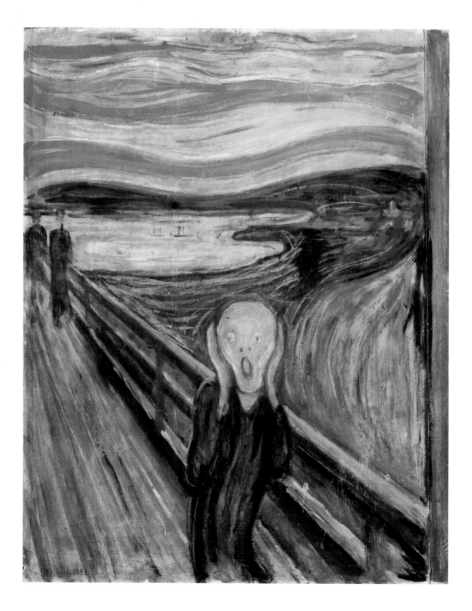

**Just as Leonardo da Vinci studied
the recesses of the human body
and dissected cadavers,
I try to dissect souls.**

Edvard Munch

Cartoon by Tom Cheney for *The New Yorker*.
© Cheney / *The New Yorker* / Condé Nast

If it took the theft of the *Mona Lisa* in 1911 to transform Leonardo da Vinci's small painting into an icon of popular culture, when *The Scream* was stolen on August 22, 2004, the worldwide media coverage of the event served only to emphasize how immensely well known the work already was on a popular level. The thieves, clearly aware that they would never be able to sell such a celebrated painting, had removed it from the museum for a precisely premeditated goal, using the resulting news frenzy to deviate the attention of the Norwegian police from an investigation of an earlier theft that had concluded in homicide.

Further proof of its extreme popularity is the fact that *The Scream* had already been the victim of a theft in 1994. That time, too, it was recovered because it would have been impossible to sell in the normal market.

But why has *The Scream* become such a fetish? The first reason is that it represents modern man's plight—strangled by existential tension in the wake of two world wars and the horror of the Holocaust—in a simple fashion that is immediately and universally comprehensible on a primary emotional level. The second reason is the life story of the Norwegian artist who painted the work. Edvard Munch (1863–1944) was a man tormented to the point of madness, already devastated in childhood by the death of his younger sister and his mother, and his biography, like that of Van Gogh or Modigliani, reads like a tale of genius and desperation, exciting the public imagination and emotion.

Last but not least is a historical reason that, though unknown to the masses, has contributed to *The Scream*'s many layers of fame. In 1892, the year before he painted it, Munch had a scandalous exhibition in Berlin that was immediately shut down for obscenity. The episode granted the artist great visibility in the German art community and was fundamental in the establishment of the Berlin Secession in 1898, which in turn led to the expressionism of the Die Brücke group, founded in Dresden in 1905, whose work Adolf Hitler later branded as "degenerate art."

In 1902 the German critic Karl Scheffler wrote, "There has never existed a painter with greater desire for a lyrical

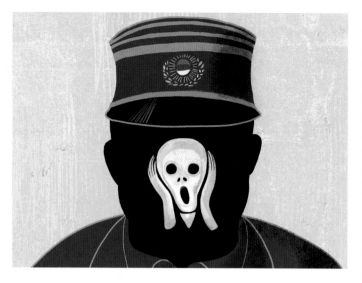

Referring to the former Bosnian Serb army commander Ratko Mladic, *Mladic* by Beppe Giacobbe was published in *Corriere della Sera* on June 13, 2011.

Inflatable *Scream* doll, 1991

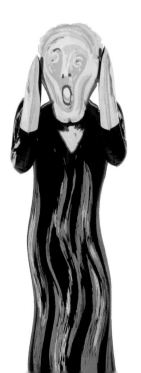

emotional life; but his unhappy intellect never allows him to forget the worm that hides in every bud, the grimace of the skull behind every face, the beast that is concealed behind every passion, the arbitrary caprices of Nature in every painful sensation." Henceforth every work by Munch, both for his fellow artists and the public, became an emblem of modernity and the rebellion against bourgeois morality.

Munch created numerous versions of *The Scream* (including in print form), but the 1893 painting in Oslo is the most striking. The artist, suffering from agoraphobia and alcoholism, described the genesis of the work in a cycle of paintings known as *The Frieze of Life*, conceived as a sequence of images that, in its totality, was meant to represent the course of existence: "One evening I was walking along a road. On one side lay the city and the fjord down below. I was tired and sick. I stopped and looked out across the fjord. The sun set; the clouds turned red like blood. I felt something like a scream through nature. I thought I heard a scream. I painted that picture, painted the clouds as if they were actually blood. The colors screamed."

Munch painted many more pictures elaborating the theme of the solitary man beset by fear amid hostile and indifferent nature, but *The Scream* remains the most celebrated. More than any other work, it succeeds in concretizing a psychological experience through universally intelligible, even facile, forms rather than symbols. Indeed, the figure in the foreground exhibits its pain right before our eyes. The work is like a mirror in which we can see ourselves reflected, identifying the figure's fear as our own.

The image functions because it has made a clean sweep of romantic melancholy, that mood of meditative and indulgent sadness characteristic of many fascinating paintings of the nineteenth century but now perceived as distant from the psychological experiences of the twentieth. The taste and spirit of the time were moving on to a harsher kind of expressiveness without frills,

Gerald Scarfe's poster art-
work for the film *Pink Floyd
The Wall*, 1982

sentimentalism, or poetry. In a word: anxiety. That's why *The Scream* eventually replaced *Laocoön and His Sons* as an image representing pain—a pain that is no longer physical but is inflected with a new existential understanding of inner psychic discomfort.

The consecration of the painting that so fully embodies the twentieth-century zeitgeist was ensured by a series of exhibitions visited by thousands of people: Oslo in 1918, Copenhagen in 1946, Brighton in 1951, Paris in 1952, Bern in 1958, Vienna in 1959, Oslo in 1963–64, Malmö in 1975, Stockholm in 1977, Milan and Rome in 1985–86, Paris in 1992, Munich in 1994, and Paris again in 1998—to name only the principal venues. In 1998, for a major Munch exhibition at the Museo d'Arte Moderna in Lugano, Switzerland, a larger-than-life inflatable doll of the screaming man was positioned in the street in front of the museum. The American company that has produced these dolls since 1991 has sold more than 450,000 of them in eleven years across twenty different countries, with the United States and Japan leading the way—though at least half of those who buy it are unaware of the fact that a painting called *The Scream* even exists. They simply recognize in the image a portrayal of their own disquietude.

"There should be no more paintings of interiors and people reading and women knitting. There should be images of living people who breathe and feel and suffer and love—I shall paint a number of such pictures—people will understand the holiness of it, and they will take off their hats as if they were in a church," Munch wrote in 1889: an early indication of how conscious he was of the revolution he had wrought in painting.

JANE AVRIL JARDIN DE PARIS
Henri de Toulouse-Lautrec

ca. 1893 Color lithograph, 131 × 95 cm — Private collection

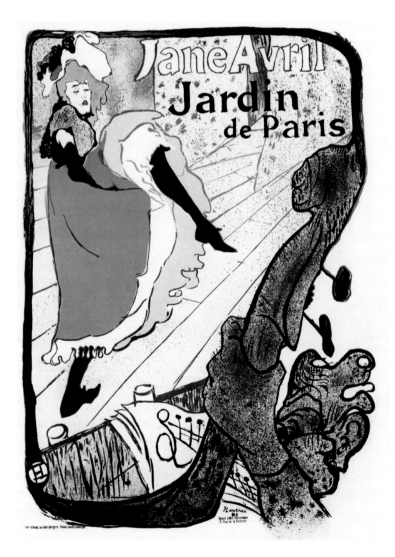

Without a doubt I owed him the fame I enjoyed from that very first moment his poster of me appeared.

...

Jane Avril

Detail of Hokusai's *The Great Wave*, ca. 1830–32

Every era has its minstrel, and the marginal and somewhat decadent underworld of the Belle Époque—the period at the end of the nineteenth century when Paris was more than ever the city of light, thanks to the World's Fair, the construction of the Eiffel Tower, and a general climate of progress and reconstruction—found its storyteller and one of its greatest architects in the figure of Henri de Toulouse-Lautrec (1864–1901), an artist blessed with extraordinary formal versatility and a true source of inspiration for French Post-Impressionism. Born and raised in Albi, in a province on the east slope of the Pyrenees, and afflicted with hereditary health issues from childhood, Toulouse-Lautrec demonstrated a precocious talent for art; around 1890 his wealthy, noble family financed his move to Paris, where he began to study with Léon Bonnat and came into contact with the quarter of Montmartre, a mecca for dancers, artists, and bohemians. Intrigued by the milieu, he made it his permanent home, using it as a source of inspiration and adopting the role of official chronicler, documenting the cafés, theaters, streets, and above all the characters who populated that nocturnal and vaguely licentious world with the detachment of a foreign correspondent and the perspicacity of a careful observer of the human condition. One place that particularly caught his attention was the Moulin Rouge, the entertainment spot opened by Charles Zidler and Joseph Oller in 1889 where the can-can was launched, and a destination of choice for the Parisian upper classes looking for transgression.

During one of his frequent visits to the cabaret, Toulouse-Lautrec met an aspiring young actress who was destined to change his art radically. This was Jeanne Beaudon, known by the stage name of Jane Avril or La Mélinite, in reference to the powerful explosive. The two immediately formed a friendship and a bond based on the proverbial attraction of opposites. The cerebral, aristocratic, and physically handicapped artist, guided at least in part by voyeurism, began to devote an enormous amount of energy to this voluptuous dancer of humble origin, immortalizing her in a series of portraits. Thanks to the innovative visual language he deployed, the works came to symbolize a pact in which the pair formed a

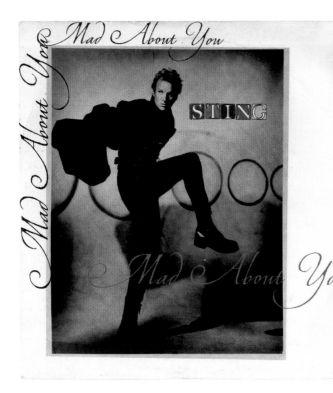

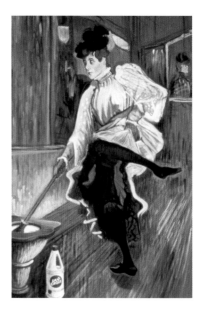

Cover of the Sting single
"Mad About You," 1991.
Photograph by Guzman

Ad for Lacroix bleach, 1991

society of mutual exploitation in order to satisfy their egos and personal ambitions. Avril saw Toulouse-Lautrec's attentions as a way of rendering permanent the fleeting nature of fame, while the artist, for his part, understood that his association with the star of the moment would grant him an importance that went beyond the narrow circle to which a successful painter was normally confined. Notoriously shrewd in financial matters, Toulouse-Lautrec had no scruples about commercializing his art and lent his talents to the creation of posters and illustrations advertising the activities of the lively area in which he lived. Notwithstanding his prolific output, the number of drawings, sketches, paintings, and illustrations dedicated to Avril alone over the course of their ten-year association is so gargantuan that in 2011 London's Courtauld Institute mounted an exhibition, *Toulouse-Lautrec and Jane Avril: Beyond the Moulin Rouge*, centered exclusively on the theme.

Whereas Toulouse-Lautrec's paintings betray a latent melancholy, as if to suggest what happens once the lights go out and the music stops, his illustrations betray none of this existential worry, presenting instead an utterly swaggering and exuberant face. This is evident in the poster he made around 1893 to promote Avril's move from the Moulin Rouge to the prestigious Jardin de Paris on the Champs-Élysées. A perspective play unfolds between the figures of the dancer and the bass player, with the musician's instrument in the foreground forming a frame that emphasizes the true protagonist of the scene, immortalizing Avril in a pose similar to one displayed in a rare black-and-white photograph of her from this period. The composition projects a momentum that is comparable to, and surely borrowed from, *The Great Wave* by Katsushika Hokusai, an artist whose biographical eccentricities and stylistic abilities made him, in the wake of Japonisme, a reference point for a generation of

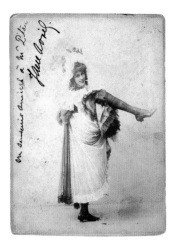

Portrait of the dancer
Jane Avril, 1893

Miss Piggy in the pose
of Jane Avril with Kermit
the Frog, 1983. The image
was part of *Miss Piggy's Art
Masterpiece Calendar 1984:
Treasures from the
Kermitage Collection*
(Alfred A. Knopf, 1983).
© Henson

European artists.

Toulouse-Lautrec's ability to describe the splendors of his time contributed in no small amount to the construction of its mythology, and his work became a touchstone for the world of theater. Films dedicated to the events that revolved around the Moulin Rouge—one by John Huston in 1952, another by Baz Luhrmann in 2001—were explicitly influenced by this perspective, as was the formula of Jim Henson's *Muppet Show*, a family-oriented television show that fully explored the phenomenon of entertainment, from the wings backstage to the orchestra pit. Even Sting didn't fail to notice it, striking a pose that openly recalls Avril on the cover of his single "Mad About You" (1991).

Toulouse-Lautrec and Avril would go their separate ways within a few years—the former descended into a spiral of alcoholism, leading to his death in 1901, while the latter sought redemption in marriage, left Montmartre forever in 1910, and died in a Paris hospice in 1943. But the result of their brief, intense alliance has unquestionably stood the test of time, with posterity consigning both muse and artist to the era that created and ultimately destroyed them.

WATER LILY POND, GREEN HARMONY
Claude Monet

1899 Oil on canvas, 90 × 93 cm — Musée d'Orsay, Paris

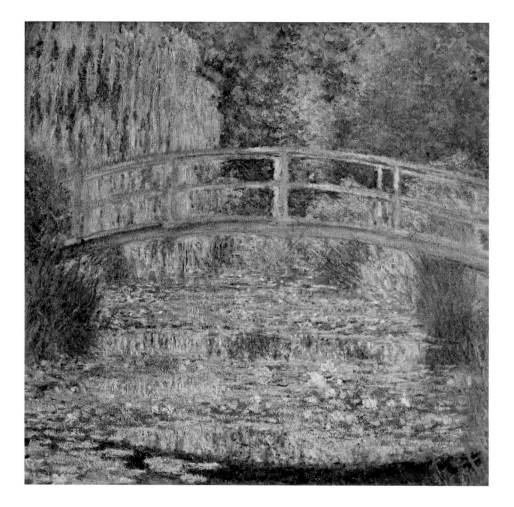

**My only virtue resides
in my submission to instinct:
it is from having recovered
and allowed to predominate
the intuitive and secret forces
that I was able to identify myself
with creation and absorb
myself in her. . . . I have arrived at
the final stage of abstraction and
of imagination allied with reality.**

Claude Monet

Bracelet of gilded brass and colored resin,
inspired by Monet's *Water Lily* paintings and
produced by the Réunion des musées
nationaux, Grand Palais, Paris, 2009

Claude Monet (1840–1926) devoted the last twenty-seven years of his life and approximately two hundred canvases to the theme of water lilies. At first he painted the flowers in an expanded field, including the Japanese bridge built over the pond on his property in Giverny, France. Then he began to eliminate even the surrounding trees, and finally the edges of the pond, until there remained only lilies—pink, white, yellow, or red—in a limitless space where water and sky would converge. Analyzed together in all of their variations, these paintings of the aquatic flowers that the artist had ordered from Japan represent the end point in Monet's research on light: a dissolution of form that opened the way to abstract painting. As the artist once said, "I want to paint . . . only the beauty of the air."

Monet's *Water Lily* paintings reached their apex of popularity in the 1980s, but they did not always enjoy such degree of acclaim. The low point seems to have occurred after Monet's death in 1926, when the French state gave the paintings their own Paris museum, the Musée de l'Orangerie. It was an idea Monet himself had suggested in a letter to his friend Georges Clemenceau (the then head of French government) in November 1918, following the armistice ending World War I, when the artist announced his intention to donate two *Water Lily* panels to France in commemoration of its victory. A monumental group of nineteen panels was installed on May 17, 1927, transforming a reception hall into an enveloping, physically immersive oval space without borders and horizon. Regrettably, too many years had passed since the initial project. By the 1920s, public taste had been converted first by Cubism and then by the neotraditional goals of the so-called Return to Order, which pushed aside the dissolved volumes and forms of Impressionism. The new generation of artists and audiences preferred an art based on geometric values, which came to be known as Rationalism and which was far from Monet's infinite, fluid, decorative, intuitive world, now linked in the public imagination with the nineteenth century and Art Nouveau. "Yesterday I went to the Orangerie," wrote Clemenceau on June 2, 1928. "No one else was there."

Ad by DDB Brasil for the Museum of Art of São Paulo featuring a Monet work from the museum's collection transformed into a TV, 2004

Promotional material for the dance performance *Nymphéas*, inspired by Monet's *Water Lily* paintings, 2013

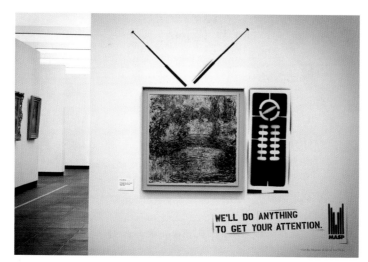

For more than half a century the museum stood as a grand, anachronistic monument until, as at the start of Monet's career, success came once more from America. When dealer Paul Durand-Ruel exhibited Impressionist paintings by Monet, Manet, Renoir, Pissarro, Sisley, Cassatt, Morisot, and Seurat in New York in 1886, the artists finally found the approval that had been denied them in Paris. Renoir went even so far as to note, "We perhaps owe it to the Americans that we did not die of hunger." About a century later, Monet's work once again would find itself in tune with the spirit of the time. The 1980s marked a period of disengagement after years of demonstrations in the streets, a moment when fashion and luxury triumphed and of stock-market euphoria. It was, above all, a time characterized by the desire to capture a fragile moment of pleasure and beauty—precisely what Monet had described in his *Water Lily* paintings. Their ephemeral and almost intangible quality, resonating so strongly with the carefree outlook after years of social and political turmoil, returned the Impressionists to favor. If Van Gogh was the tormented social outcast, the Impressionists were rebels who shattered the bourgeois rules of the nineteenth century and made their fortunes, just like the nouveau riche Americans and Japanese. And when there is an influx of so much money, art becomes both a hedge against inflation and a status symbol. Prices begin to rise, with the media serving as a sounding board for record highs on Wall Street. Monet's approachable and disengaged painting could please everyone, without exception. Museums exhibited his works from Cairo to Tokyo; everyone could see and talk about them, everyone recognized them and bought reproductions in the form of posters and postcards.

Another reason for Monet's newfound success may be attributed to the thread that, as early as the previous

Tessa Traeger
Monet Bridge, 1989
Cibachrome, ed. 10,
91 × 91 cm

Peter Rösel
Lily Pond, 1997
German police uniforms and
hats, dimensions variable
Museum für Moderne
Kunst, Frankfurt

century, had connected the artist with Japan. Monet himself had chosen Ando Hiroshige's prints to decorate his yellow dining room in Giverny. Even the concept of seriality that the French artist adopted for his cathedrals and water lilies had been inspired by Japanese art, including Hiroshige's celebrated *One Hundred Famous Views of Edo* and *Thirty-Six Views of Mount Fuji*.

When the Musée de l'Orangerie devoted a large-scale exhibition to Monet in May 1999, just before the institution shut down for renovation, the time was ripe for the work to be embraced anew. Monet became once more a popular phenomenon for discussion in newspapers and on television—a name recognized by all and associated, first and foremost, with his water lilies.

THE KISS
Gustav Klimt

1907–8 Oil on canvas, 180 × 180 cm
— Österreichische Galerie Belvedere, Vienna

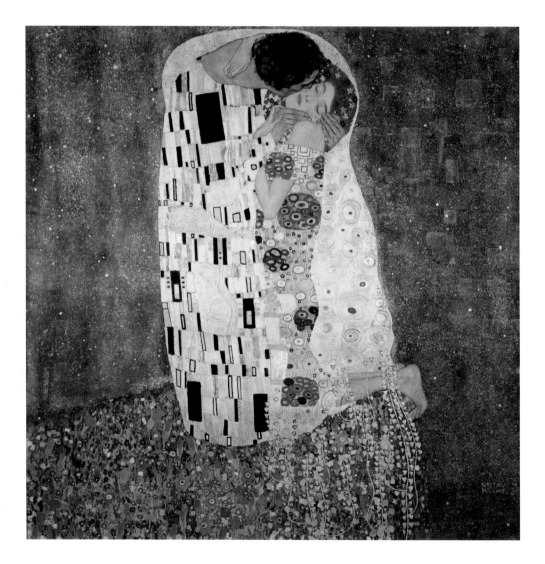

All art is erotic.

............................

Adolf Loos

One of the components for the transformation of a painting into an icon is the reputation of the artist— even better if scandalous. The celebrity of the Austrian artist Gustav Klimt (1862–1918), unlike that of Vincent van Gogh (inspired by the madness with which he was afflicted) or Salvador Dalí (who was known as a real eccentric), was built principally on morbid eroticism. In the sexually phobic, puritanical Vienna of the nineteenth century, where pathologies were beginning to come to light in Freud's case studies of hysteria, Klimt's paintings of perturbing femmes fatales aroused outrage, censorship, and even a parliamentary interrogation accusing the artist of pornography and "frustrated perversion." The women in his work, with their wild loose hair, febrile slenderness, and demonic sensuality, in fact mirrored a fear of eros that permeated the emasculating society of the time. Klimt turned this into the principal subject of his work, inevitably fostering the more or less credible stories that developed around his own persona, including tales about the haute bourgeois women he portrayed nude and then clothed in marvelous floral or gilded garments, or the model-lovers who besieged his studio and whom the artist enjoyed receiving wearing a long, loose shirt like a sort of holy man.

Vienna's Österreichische Staatsgalerie acquired *The Kiss* in 1908 as a masterpiece from *Kunstschau Wien 1908*, the first official exhibition of the group of artists (known unofficially as the "Klimt group") who broke with the Viennese Secession in 1905. The painting has nothing that had not already been seen in previous works from the artist's so-called golden period, including the square, rectangular, and spiral decorative elements in the garments; the flower-studded base; and of course the gold background, which references the medieval concept of space as a divine, infinite, and immeasurable place. It is worth noting that the theme of the embrace had also appeared in Klimt's earlier work, both in his *Beethoven Frieze*, created for the fourteenth Secessionist Exhibition in Vienna (1902), and in his *Stoclet Frieze* for the Palais Stoclet in Brussels (1905–11). And yet *The Kiss* has unquestionably become Klimt's best-known work. Why?

A primary reason resides in its particular sensuality.

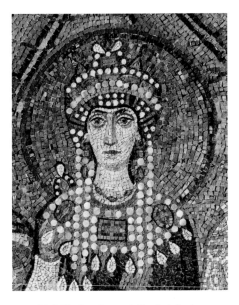

Detail of the Byzantine mosaic *Theodora's Court* (bust of Theodora) in the Church of San Vitale, Ravenna, 547

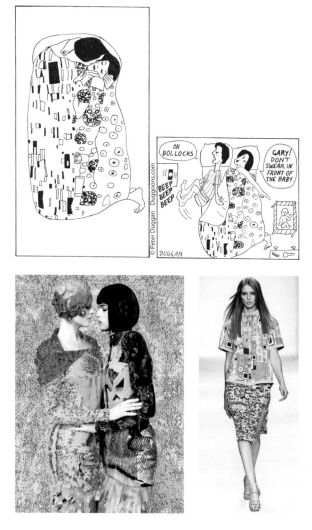

Peter Duggan's "artoons" *Klimt Revised*, first published by guardian.co.uk, June 1, 2011

Photograph by Erik Madigan Heck published in *Nomenus Quarterly*, April 2012

Aquilano.Rimondi dress by Tommaso Aquilano and Roberto Rimondi, summer 2011. Model: Alina Zaharia

Even though there is little nudity (only the hands, feet, and a shoulder), the composition expresses a potent erotic charge through the abundant use of gold, the position of the lovers' heads, and above all the woman's face: languidly abandoned, eyes closed, and held between the man's hands. Describing the sublimation of desire through gesture—the arch of a woman's neck or a man's shoulders, the movement of an arm, the curve of a hip, an oblique glance—Klimt created an image that could be broadly disseminated and accepted by diverse audiences, from the most advanced to the conservative and even the sexually phobic. Another aspect that should be pointed out is that the typical Klimtian theme of woman's dominance over man is here completely reversed. His earlier depictions of Judith, nymphs, and water snakes, even his *Nude Veritas*, all portray dangerous and intuitive women, haughty and contemptuous enigmas of nature, immersed in ambiguous backgrounds with pollen, pistils, ova, and spermatozoa scattered across their bodies, in the water, garments, and landscapes and sometimes on the frames. But the woman in *The Kiss* is a gentle and subdued creature who allows herself to submit to and be absorbed in unity with her lover. Frozen in embrace, she recalls a graceful, dreamy, and sinuous Botticelli more than the dangerous and hysterical man-eaters of a society that had reached a point of decline, where the allure of decadence and the decay of empire went hand in hand.

The second element that should be taken into consideration is the mantle that envelops the protagonists in the painting. Shortly before painting *The Kiss*, Klimt had gone to Ravenna, Italy, where he visited the Church of San Vitale and was struck by the Byzantine mosaics that decorated the apse (particularly those dedicated to the Emperor Justinian and his wife, Theodora). Translated and recontextualized within Klimt's oeuvre, the sparkling motifs that hide/define the bodies of the two lovers add an oneiric atmosphere that confers on the entire work a touch of romanticism mixed with sensuality.

After Klimt's death, the drama of two world wars and the somber and abrasive art that followed did not curry favor for his style, which was considered decorative and

decadent like all of Art Nouveau. Klimt's fame began to climb again and was fully restored in the late 1950s, amid a more airy, beauty-prone climate, when Otto Benesch and Hans Gold decided to include his work in the Austrian pavilion at the 1958 Venice Biennale. It was an apparently conservative gesture—Klimt had already represented Austria in 1899 and 1910, and was from an earlier generation than other artists selected, such as Georg Ehrlich and Hans Fronius—but it proved fortunate, opening the way to a series of retrospectives that included the University Art Gallery in Berkeley, California (1963), and the Solomon R. Guggenheim Museum in New York (1965). Finally, in April 1968, the Albertina in Vienna mounted a major retrospective of Klimt's work on the occasion of the fiftieth anniversary of his death, consecrating the international extent of his celebrity.

One of the most interesting explanations for why Klimt's *Kiss* emerged in the 1960s as a symbol of seduction and decoration, inspiring the creativity of legions of designers and advertising executives, may be found in art historian Rossana Bossaglia's observations on Italian Art Nouveau. "It seems specially made to console art lovers with an unrestricted pleasure in the beautiful or the pleasurable," she writes, seemingly describing the repeatable, schematically clean, and easily assimilable style that characterizes the artist's work. "It stands in opposition to the expressionist and proto-rationalist currents, rejecting any interest in the moralizing task of artistic activity."

The representation of love and the use of decoration as an element of pleasure: this, then, is the secret of *The Kiss*, which has ended up becoming an emblem of opposition to art that is mired in excessive conceptualism at the expense of visual accessibility. And yet the power of an image, once it has become an icon, resides precisely in its capacity to act transversally, acquiring new and unexpected meaning. This is, for example, the case in a mural created in Damascus in January 2013 by the Syrian artist Tammam Azzam, in which the bullet holes pitting the facade of a building become part of the fabric of the lovers' cloak, transforming *The Kiss* from a decorative work par excellence into a civil and political message of peace.

DANCE
Henri Matisse

1909–10 Oil on canvas, 260 × 391 cm
— The Hermitage, Saint Petersburg

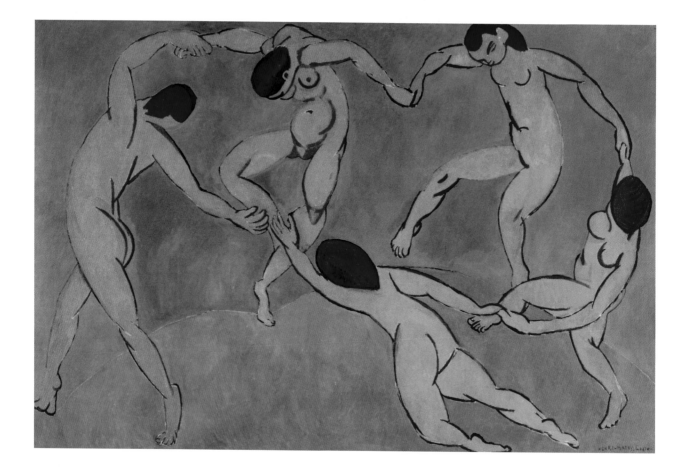

When I had to compose a dance
for Moscow, I had just been to the Moulin
de la Galette on Sunday afternoon.
And I watched the dancing. I especially
watched the farandole. . . . The dancers
hold each other by the hand, they run
across the room, and they wind around
the people who are milling about. . . .
Back at home I composed my dance
on a canvas of four meters, singing
the same tune I had heard at the Moulin
de la Galette, so that the entire
composition and all the dancers are
in harmony and dance to the same rhythm.

Henri Matisse

There is no doubt that the popularity of *Dance* is largely due to its simplicity: a total of three colors (the blue and green of the pine trees standing out against the sky of the Côte d'Azur, as the artist explained, plus red) and five figures (barely sketched out, as featureless as mannequins), signifying the merging of humanity and nature.

Yet with so few ingredients Henri Matisse (1869–1954) created one of the icons of the twentieth century, one whose essential nature speaks directly to the viewer in an intuitive language unmediated by rationality. Even the "ring around the rosie" formation is an image we have known since childhood, taking us back to a time of unconscious spontaneity and pure joy. This quality was immediately understood and appropriated by advertising, public relations, art, and photography—as in the famous Christmas card showing reindeer dancing with Santa Claus, or in the orbit of dancing priests captured by photographer Mario Giacomelli in the 1960s.

A simple ring of dancers cannot suffice to explain the success of the work, though. What in fact conveys the sense of delight is their irregular position. Breaking the rigidity and Apollonian perfection of the circle, the chain of figures discovers a Dionysian rhythm evoking laughter and excitement.

The painting is the result of a commission from the Moscow collector Sergei Ivanovich Shchukin, a wealthy textile merchant who wished to decorate the walls along the grand staircase in his mansion. His friend Matisse proposed three panels: a dance for the first floor, an allegory of music for the second floor, and for the top floor a scene of relaxation, with a series of pensive or dreamy individuals stretched out on the grass. "I will achieve all this through the most simple and minimal means, those that allow the painter to express fully his inner vision," the artist wrote in 1909. The subject of the dance had been on his mind since at least 1905–6, when he included a halo of dancing figures in the background of *The Joy of Life*, a painting today in the collection of the Barnes Foundation in Philadelphia.

Matisse was at that time in his forties and quite clear about his artistic goals: "What I dream of is an art of balance, of purity and serenity, devoid of troubling or

TELLURIDE FOUNDATION

disturbing subject matter, an art which could be for every mental worker, for the businessman was well as the man of letters, for example, a soothing, calming influence on the mind, something like a good armchair which provides relaxation from physical fatigue." He viewed painting as decoration, as a serene and joyful aesthetic emotion. This is precisely the opposite of what was being sought by Pablo Picasso, who posited painting as an intellectual exercise for understanding reality through works such as *Les Demoiselles d'Avignon* (1907) and *Guernica* (1937), the universal symbol of the brutality of war. If Matisse's art is one of abandon that gives in to life, Picasso's is all about interpretation. The distinction is so evident that even the advertising industry, which is known for co-opting everything that works in art, has seldom attempted to exploit Matisse's icon in a dramatic or satirical way.

Yet *Dance* was a fiasco when it was first shown, alongside *Music*, at the Salon d'Automne of 1910. Critics competed to publish negative judgments and only Apollinaire defended the two canvases, which presented, albeit using

a new vocabulary, a late nineteenth-century aesthetic favored by the Symbolists. Far from being the popular success it is today, *Dance* seemed little more than a parody of the common Art Nouveau subject of dancing female figures.

Even Shchukin had his doubts, but he eventually came to terms with the work. On November 11, 1910, he put pen to paper and wrote Matisse from Moscow: "Dear sir, while I was traveling (two days and two nights) I reflected a great deal, and I have come to feel ashamed of my weakness and lack of courage. One must not desert the field of battle without attempting the struggle. For this reason I have decided to hang your panels. They will shout, they will laugh, but I am convinced of the rightness of your path; perhaps time will be my ally and in the end I will be victorious. I have sent a telegram requesting that you send the panels to Moscow by express train."

Matisse's *Dance* reinterpreted
by the Brazilian street artist
Zéh Palito in a mural in São
Paulo, 2011

Roy Lichtenstein
Artist's Studio
"The Dance," 1974
Oil and synthetic polymer
paint on canvas, 244 × 326 cm
The Museum of Modern Art,
New York

Mario Giacomelli
Io non ho mani che mi accarezzino il volto (*I Do
Not Have Hands that Caress My Face*), 1963
Gelatin silver print, 30 × 40 cm
Private collection

AMERICAN GOTHIC
Grant Wood

1930 Oil on beaver board, 78 × 65 cm
— The Art Institute of Chicago, Friends of American Art Collection, 1930.934

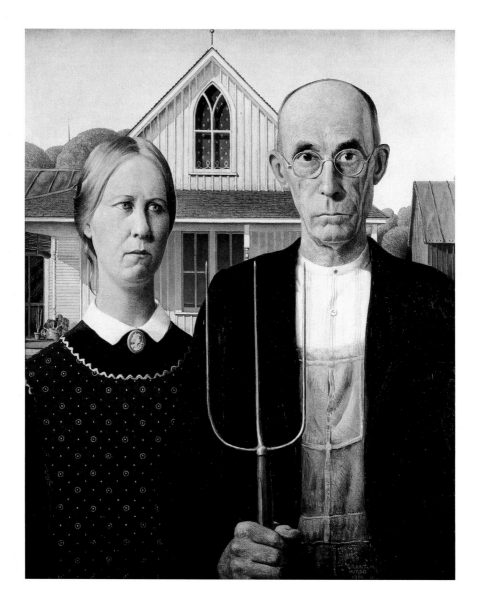

Everybody has their own America, and then they have the pieces of a fantasy America that they think is out there but they can't see.

Andy Warhol

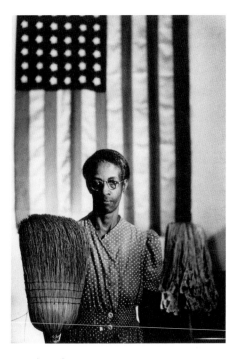

Gordon Parks
American Gothic, Washington, DC, 1942
Gelatin silver print

American Gothic is one of the rare works of art, excluding those from antiquity, that have succeeded in becoming icons without a heavyweight name to prop up the myth. In Europe, in fact, most people recognize it without even knowing the name of the painter, Grant Wood (1891–1942), an artist also marginalized by many American art historians who consider his work out of step with the New York avant-garde movements of the early twentieth century.

Wood himself was the first to be amazed by the painting's reception. Prior to creating it, the only prize he had ever won was from the Iowa State Fair, and he had never sold a single painting to a museum. But *American Gothic,* made during the Great Depression and shipped to the annual exhibition at the Art Institute of Chicago, ended up winning the bronze medal and a prize of three hundred dollars, to which a support group of the Art Institute, the Friends of American Art, added another three hundred for purchase of the work.

Critics were immediately divided over how to interpret the painting. Some believed that Wood's representation of the rural couple was a caricature, while others thought it was a celebration. In the Chicago press, Charles Bulliet called *American Gothic* "quaint, humorous, and AMERICAN," while a Boston critic described the pair as forbidding religious fanatics. The farther away one got from the Midwest, the more the painting was read either as a satire, a social critique, or a manifesto for conservative values.

What everyone agreed on was its distinctly American quality. In 1941, as World War II raged in Europe, *Fortune* magazine proposed the painting as the perfect anti-German propaganda poster, publishing it above the famous words from Abraham Lincoln's Gettysburg Address: "Government of the people, by the people, and for the people shall not perish from the earth."

At a certain point, Wood, a simple, awkward man in real life, clumsily tried to go along with the ideas of critics who brandished his art as the antidote to the avant-garde eccentricities of the East Coast. He had in fact painted with spontaneous, nonideological affection the provincial descendants of pioneers who lived on in the

small towns of Iowa, resisting urbanization and poverty, and among whom he had been raised (his father was a Quaker). "I did not paint them under," Wood explained, "but to me they were basically good and solid people."

The artist had first seen the wood house with the Gothic window, built in 1882, in August 1930 while visiting Eldon, a small town in southern Iowa, at the invitation of the director of the Little Gallery in Cedar Rapids. He made a pencil sketch, and then an oil study, and finally he had it photographed. Once he returned home, he found the models for the farmer couple—his thirty-two-year-old sister, Nan, and his sixty-two-year-old dentist, Dr. B. H. McKeeby. Their Victorian air was inspired by old albums made by traveling photographers that showed rural families posing in front of their homes with their tools of trade, in which the subjects seem to stare out at the viewer, their bodies rigid, their faces silent and cryptic.

Upon its debut, *American Gothic* enjoyed a certain success with that portion of the public who saw in it a portrait of the nation: an archetype of the humble family that was the country's social foundation. Without symbols

to decipher, the painting described puritan roots, life on the frontier, the self-sufficiency of the nuclear family, and the Protestant work ethic on which American morality is based—values around which the painting consolidated collective sentiment during a moment of social bewilderment like the Great Depression. But in the 1940s, as America became caught up in World War II, many started to associate the painting with a nationalistic and isolationist spirit that seemed ingenuous, lacking in heroism, and obsolete. The social and political panorama had utterly changed, and the country no longer viewed itself as inward looking, but rather as an economic, military, and cultural power of international significance.

The fortunes of *American Gothic* began to change, however, during the late 1950s. This is when the first parodies appeared, and its newfound use in advertising raised it to icon status. Charles Addams, for example, published a cartoon in *The New Yorker* that showed the couple from *American Gothic* exiting the galleries of the Art Institute of Chicago as the museum attendant gawks, speechless. But it was in the late 1960s that the image was appropriated by the mass media, precisely because

Cover of the Astrovamps album *Amerikan Gothick*, 2004

Gary Locke separated the couple in Wood's painting and added a house to illustrate the cover story "A Nation of Singles," *The Weekly Standard*, 2012

Charles Addams's *American Gothic Skiers*, a preliminary watercolor for an unpublished magazine cover, 1976

it proved susceptible to diverse and opposing interpretations, just as it had been received by critics from the start.

As the art historian Wanda Corn has observed, "With a simple change of clothes, faces, tools, or surroundings, parodists have proved that the couple can represent almost any kind of American: rich or poor, urban or rural, young or old, radical or redneck, and, on rare occasions, black as well as white." In place of Nan and Dr. McKeeby's severe faces, for example, have appeared the countenances of former US presidents Jimmy Carter, Ronald Reagan, and their respective first ladies. Instead of the dentist brandishing a pitchfork, we might find an actor or a model holding a tennis racket. In 1970 *Silent Majority: The Magazine for Middle America* published a cover showing the *American Gothic* couple flanking the then president Richard Nixon, who affectionately rests his hands on their shoulders, signaling his conservative politics and his alliance with the people. In advertising, where the pair is viewed as the perfect representation of Mr. and Mrs. Average America, the image has often been appropriated to advertise radios, computers, and cameras, exploiting the visual frisson between the high-tech device and the old-fashioned couple. In 1979 the magazine *Working Woman* adapted the image for a cover promoting a story called "Where Women Leave Their Men Behind"; the photo shows a dynamic young woman in a modern pantsuit walking briskly away from a dumbfounded man who is a dead ringer for the elderly Dr. McKeeby. Yet this seems to be the exception rather than the rule. As Corn again points out, only rarely has *American Gothic*'s iconography been borrowed to address other divisive issues such as the Vietnam War, poverty, the gay rights movement, or racism.

THE PERSISTENCE OF MEMORY
Salvador Dalí

1931 Oil on canvas, 24 × 33 cm — The Museum of Modern Art, New York, given anonymously

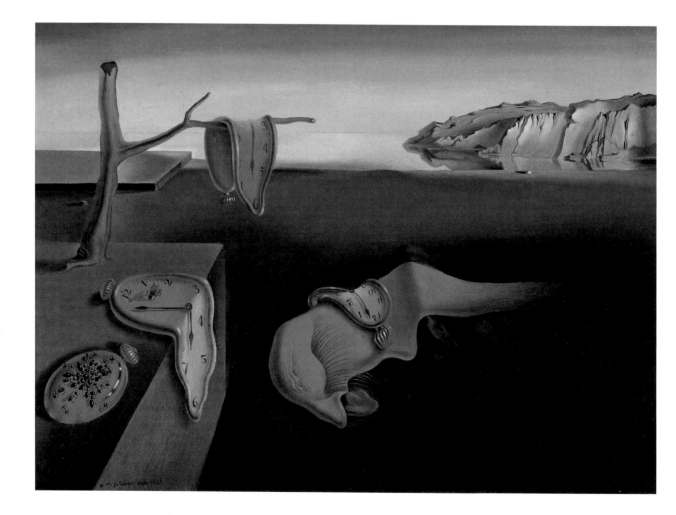

I realized,
I created my persona,
I discovered love,
painted my work,
built my house on these shores.
I am inseparable from
this sky, this sea, these rocks.
It is not only a question
of feelings but of physical,
biological and surrealist reality.

Salvador Dalí

Compared to the other works in this book, *The Persistence of Memory* is an atypical case. At first analysis, this painting by Salvador Dalí (1904–1989) seems to lie outside all criteria that sanctify an artwork as an icon. Modest in size, it does not represent a universal ideal of beauty, as does Botticelli's *Birth of Venus*; it does not portray a historical moment, like Delacroix's *Liberty Leading the People* or Picasso's *Guernica*; it does not construct an innovative chromatic architecture for abstraction, such as Piet Mondrian's series of white, red, blue, and yellow compositions; and, finally, no one single detail has been reproduced incessantly until it receives official approval as an icon, as, for example, with the apple in René Magritte's *Son of Man*. What, then, is the secret that transformed the apparently illegible *Persistence of Memory* into a composition that has left an indelible mark on the collective imagination? Had Dalí been born twenty years later, at the time of Andy Warhol, one might impute at least a portion of success to the author's aptitude for exploiting the mechanisms of the entertainment industry. And although Dalí did make some attempts in this direction through his association with figures like

Alice Cooper and Amanda Lear, he is still part of an earlier generation, namely the first wave of painters of the twentieth century.

The difficulty in categorizing *The Persistence of Memory*, however, coincides perfectly with Dalí's flamboyant personality. His exaggerated individualism, coupled with an abundant dose of eccentricity, was already evident in the 1920s. Expelled from Madrid's Real Academia de Bellas Artes after only one year for criticizing his professors, rejected by his family for taking up with Elena "Gala" Diakonova (Paul Éluard's ex-wife and ten years Dalí's senior), ousted by the Surrealists for his neutrality toward the events leading up to the Spanish Civil War, Dalí followed the path forged by his compatriots Pablo Picasso and Joan Miró with a combination of respect and suspicion, stimulated by their encouragement and formal breakthroughs but incapable of severing the cord to more traditional art forms. This position of middle ground, which certainly helped cement his role as an outsider, would end up defining much of his artistic journey, including *The Persistence of Memory*, a work that even in its title reveals a conflicted relationship

between past and present.

The metaphysical landscape in which *The Persistence of Memory* is set is Port Lligat in northeastern Spain, where Dalí spent his childhood and where he probably created the painting. The angularity of the mountain range (a possible reference to Cabo de Creus in Catalonia), the tree at the left, and the platform below is blunted by a soft central presence—perhaps a sexual hint, perhaps a self-portrait of the artist, or most likely both (a similar form dominates *The Great Masturbator*, painted two years earlier). But the principal figures are the four watches—three liquefied timepieces indicating different hours, one closed and covered with insects—oneiric symbols of existential concerns such as the passing of time, the imminence of death, the torment of the past, and the distressing desire to control everything. For years this "viscous" illustration of the tie between spatial and temporal dimensions would provoke the imagination of those critics who persevered in furnishing the most contorted interpretations, including one claiming that *The Persistence of Memory* is none other than a pictorial restatement of Albert Einstein's theory of relativity. The official explanation provided by Dalí—and we don't know whether he did so out of provocation or genuine innocence—was actually much more prosaic: he claimed as his muse some pieces of Camembert cheese that he had seen in the process of melting.

Scott paper-towel ad
by JWT Kuala Lumpur, 2007

This Dalí clock of 1998 is
an example of the plethora
of Dalí-inspired gadgets
and merchandise.

The painting departed Spain in 1931 for Galerie Pierre Colle in Paris, where it was noticed by the art dealer Julien Levy, who purchased it for two hundred and fifty dollars with the intention of exhibiting it in New York. The human subconscious–filtered conflict between nature and machinery described by *The Persistence of Memory* embodied a truth with which early-1930s America could not help but identify, destroyed as it was by the financial crash of 1929 and increasingly tormented by regionalist forms of nostalgia. Its transatlantic debut was such a triumph that Levy soon decided to send the painting on a tour of New England. The main newspaper

A 2011 KitchenAid ad compares the transformative power of its mixer with the Surrealists' transformation of dreams into art. Ad by DM9 DDB Brasil, illustration by D6B Studio

in Connecticut, the *Hartford Courant*, gave it an enthusiastic reception, praising the presence of a method behind the apparent surrealist madness and—in what can only be described as an amusing cultural shift—comparing the central watch to a dominatrix's saddle. Meanwhile, the newly established Museum of Modern Art, anxious to make its presence felt in the artistic landscape of New York, acquired the painting through a gift of Helen Lansdowne Resor, a hard-core suffragette and a pillar of the J. W. Thompson advertising agency.

Judging by the advertising industry's zealous embrace of *The Persistence of Memory*, which has been used to sell everything including Lipton teabags and Scott paper towels, and even for public-service campaigns promoting the cleanup of coastal regions, the acquisition could not have been by chance. Did Resor, in light of her professional experience, detect earlier than anyone

else what Dalí had already known before giving the work such a prophetic title? "Do you think you will remember it in three years?" the Spanish artist had asked Gala, his first public test after completing the painting. Recovering from her astonishment, she is said to have broken her silence by responding, "Nobody can forget it once they have seen it."

GUERNICA
Pablo Picasso

1937 Oil on canvas, 349 × 777 cm — Museo Nacional Centro de Arte Reina Sofía, Madrid

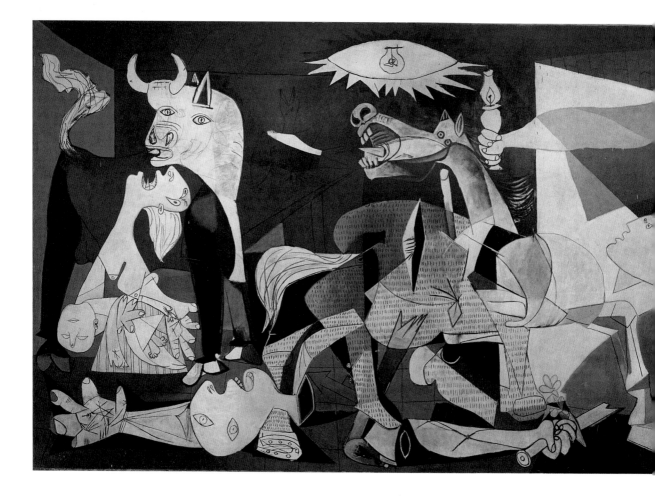

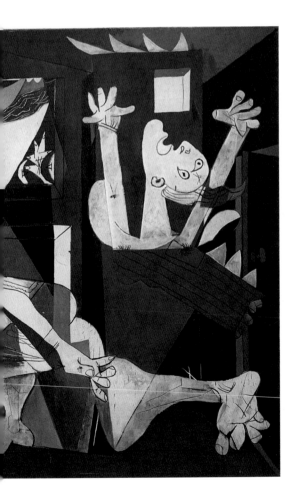

No, painting is not made to decorate apartments. It's an offensive and defensive weapon.

Pablo Picasso

The exceptionally powerful image of *Guernica* did not become an icon over time: it immediately emerged as one. In the history of painting it is what is referred to as a "primary object"—the media spotlight was already focused on it at the time of its inception, becoming an instrumental component of its fame.

When it was first displayed in public in the Spanish Pavilion at the 1937 World's Fair in Paris, the monumental canvas was already a paragon for the struggle against fascism. Cut to ten years later, at the end of World War II, and its allegorical power was even greater—it had become a symbol of the barbarity of all wars as well as the most celebrated political manifesto of the twentieth century.

It took Pablo Picasso (1881–1973) only five weeks (May 1–June 4, 1937) to paint the canvas in his atelier at 7, rue de Grands-Augustins, Paris, following the April 27 bombing of the Basque town. The attack, carried out by Hermann Göring's Condor Legion, a German air force unit allied with the Spanish dictator Francisco Franco, caused the death of sixteen hundred civilians, arousing public indignation and intense emotion. Following the bombing, the Republican government appealed to Europe: "The world should know in detail the acts of extreme savagery to which the Basque population fell victim." It then commissioned Picasso, who had earlier been named director of the Museo Nacional del Prado, to create a work in support of the democratic cause and for future memory.

Opposition to the events in Guernica made the Spanish Civil War a cause for international writers and artists. From Ernest Hemingway to Pablo Neruda, from André Malraux to George Orwell to Joan Miró, they all helped alert the entire world to the tragedy. As a matter of fact, there was also some dissent among the critical responses to the painting. Although Picasso was already a star, his reputation was based on a completely different type of art, and many academics were suspicious of this unexpected incursion into the world of international politics—a doubt that a subsequent series of prints, *Dream and Lie of Franco*, made in 1937 to raise money for the Republican cause, did little to dispel.

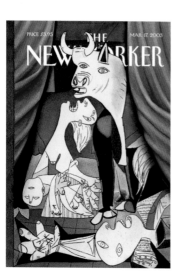

"Guernica is a disappointment," wrote the British art historian Anthony Blunt after seeing the painting in Paris. "It is not an act of public mourning, but the expression of a private brain-storm which gives no evidence that Picasso has realized the political significance of Guernica."

Many critics accused Picasso of opportunism, but disagreement coming from as small a camp as the art world could not withstand the flood of emotion unleashed by the Basque town's calamity. Guernica was a portentous visual manifesto and it was managed in a thoroughly modern fashion, beginning with documentary photographs shot day-to-day by Picasso's companion, Dora Maar, as he was painting it. And then there was attention from films such as Alain Resnais's Guernica (1950), featuring texts by Paul Éluard; Luciano Emmer's Picasso (1954); and The Mystery of Picasso (1956) by Henri-Georges Clouzot. The painting was immediately reproduced on postcards that circulated even in Nazi-occupied Paris and Fascist Italy, and, in the guise of a political propaganda poster, it was used to raise funds and galvanize support for the Republican cause. In the service of the latter the canvas toured incessantly, touching down in thirty-one cities. At the war's end it was exhibited in Italy, Germany, Brazil, and many other countries before stopping in New York at the Museum of Modern Art, where it remained until 1981.

Picasso considered himself the plenipotentiary guardian ensuring the work's correct political use, and his will explicitly stated that the painting should not be allowed to enter Spain before the fall of Franco. After the dictator's death in 1975, Guernica finally flew home on an ultramodern jumbo jet, its value judged so inestimable that no insurance company would agree to indemnify it. Its first destination was the Prado in Madrid, but since 1992 it has found a permanent home at the Museo Nacional Centro de Arte Reina Sofía. The Basque administration has made numerous requests that it be loaned, at least temporarily, for exhibition at the Guggenheim Museum Bilbao, but the Spanish government has always

"No war!" placard with an image of the screaming man in Guernica at a demonstration against the Iraq War in Washington, DC, 2003

Setting the Stage by Harry Bliss for The New Yorker references the draping of the Guernica tapestry at the United Nations on February 5, 2003. Bliss / The New Yorker © Condé Nast

Bayer Aspirin ad by AlmapBBDO Brasil associating pain with Guernica

The word Guernica alone is enough to evoke Picasso's powerful painting, as seen in this graffiti on route D783 outside Pont-Aven, France.

denied such requests, fearing that the painting would not be returned to Madrid.

Picasso himself explained the symbols that appear in the painting: the bull represents brutality, the horse the people, and the lamp the truth, which casts light on the place of horror and unmasks the lies of the fascist regime. Scholars have developed all sorts of interpretations addressing his use of black and white; perhaps the most interesting remains that of J. L. Ferrier, who linked the monochromatic palette to the May 1, 1937, front page of *Ce Soir*, where a photograph of the bombed-out Basque city was published under the headline "View of Guernica in Flames: At Galcadano Twenty-Two German Three-Engine Aircraft Have Machine-Gunned the Population." According to Ferrier, *Guernica*, like a newspaper, can be read in pieces, in a fragmentary way that does not follow a precise sequence; furthermore, like radio and newsreels, it seems to transmit the sounds of the tragic event making Picasso "the first painter to conceive his work according to the new influence of the mass media."

The painting's enduring symbolic power was demonstrated once more on February 5, 2003—the day the then US secretary of state, Colin Powell, held a press conference at the entrance to the Security Council of the United Nations to rationalize the declaration of war on Iraq. Behind Powell, a large tapestry replicating *Guernica* was draped in blue cloth (the color of the UN). It would have been awkward to urge the bombardment of Baghdad before the backdrop of a painting that has become a universal symbol for the horrors of war.

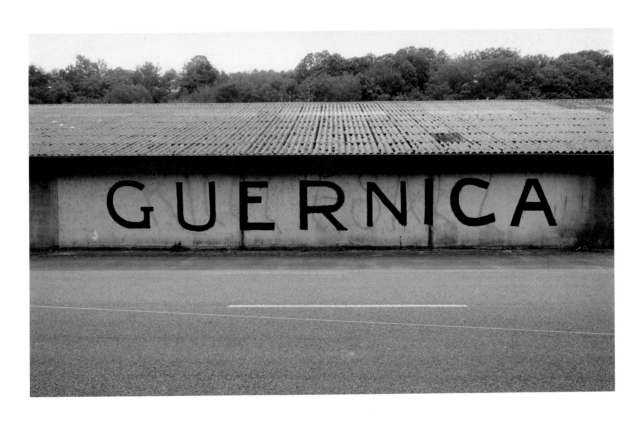

THE BLUE, YELLOW, AND RED COMPOSITIONS
Piet Mondrian

1920–42

Reconstruction of Mondrian's Paris studio at the
exhibition *Mondrian / De Stijl*, Centre Pompidou, 2010–11

**Even the most abstract art
does not arise from an
inner source alone.
As in all art, its origin is
in the reciprocal action of the
individual and environment
and it is inconceivable
without feeling.**

Piet Mondrian

Shiro Kuramata
Homage to Mondrian, 1975/2009
Matt-lacquered cabinets with doors and drawers
inspired by Mondrian's graphic works
Produced by Cappellini

Of all the tendencies that have characterized modernism, the events connected with the conception and development of abstract art are undoubtedly the best documented. Attempts to define its theoretical structure have been disseminated in countless articles, journals, books, and manifestos, revealing how the enthusiasm of post–World War I reconstruction went hand in hand with a need to give structure to an art form defined by utopian ambitions. In such a complex climate, a predominant position was occupied by De Stijl, a movement founded by the Dutch designer and critic Theo van Doesburg in 1917 that included figures such as Bart van der Leck, Robert van't Hoff, Vilmos Huszár, Jacobus Johannes Pieter Oud, Georges Vantongerloo, and, above all, Piet Mondrian (1872–1944).

Born and raised in the security of the rural Netherlands, in a family with artistic inclinations (his father was a drawing teacher, his uncle a Sunday painter), Mondrian enrolled at the fine arts academy in Amsterdam in the late 1800s and immediately demonstrated a curiosity and talent for naturalism and Post-Impressionism. A trip to Paris in 1911 gave him his first exposure to the Cubist experiments of Georges Braque and Pablo Picasso, stimulating an interest in rendering reality geometric—an attitude perhaps underscored by the decision to change his surname from Mondriaan to Mondrian. Forced to return to Holland with the outbreak of World War I, Mondrian visited the small town of Laren and got to know Van Doesburg and his acolytes, discovering the formal rigor that allowed him to finalize his emancipation from figurative painting—a combination of instinct and rationality that he christened Neoplasticism. Toward the end of 1919 Mondrian introduced a motif that would become a recurring element in his art: a black grid built on rectangular shapes occasionally filled with the three primary colors (red, blue, and yellow). His work reached its definitive evolution in 1921, when, according to the éminence grise of abstraction, Michel Seuphor, Mondrian attained "The true departure. The canvases from this year are all remarkable. . . . The black lines, which are now much cleaner, divide the surface into several rectangles of varied dimensions and

isolate the planes of color that tend to become less numerous." These compositions—which, for Mondrian, got at the core of the imbalance between conscious and subconscious, immutable and mutable—occupied his thoughts and hands almost obsessively for the next decade. The result was the creation of a unique subject that, reproduced over and over through a series of infinite yet subtle variations, determined a style so completely recognizable that it is impossible to single out one work that best represents the series. Instead, Mondrian's abstractions in blue, yellow, and red on white fall into the more democratic and even epic idea of the macroscopic and fragmentary oeuvre—a typical characteristic of the formal obsessions that mark many pages in the history of art.

For Mondrian's mentor Van Doesburg, such ideological independence on the part of one of his pupils constituted a threat, one that had to be dealt with in no uncertain terms. In 1924 he voiced his dissent, writing, "If one disregards the figures, a picture by Ingres or Poussin is identical to one by Mondrian. What I call new, on a moral and spiritual level of our time, is precisely the opposite. We are interested in antigravitation, obliqueness, a feeling different from color." It was a rather dramatic about-face for someone who only three years earlier had hailed Mondrian as "the father of Neoplasticism"; as such, it sanctioned Mondrian's defection from that group and the end of the De Stijl adventure. The beginning of World War II prompted Mondrian to seek refuge in the United States, radically altering the course of his research. The paintings he created through 1942 continue to reflect the neoplastic spirit of the 1920s (albeit with interesting variations), but his late period above all shows the influence of the panorama and culture of Manhattan, starting with the series that would culminate with *Broadway Boogie Woogie* (1942–43) and *Victory Boogie Woogie* (1942–44).

Predictably, Mondrian's death coincided with a reassessment of his work, but the true turning point was the Venice

Wenn wir mit Kunstwerken auf Reisen sind, passiert ihnen garantiert nichts.

PEARLS CREEK
ART LOGISTICS
WORLDWIDE

Yves Saint Laurent shift dress, a tribute to Piet Mondrian, from the haute couture collection, autumn/winter 1965

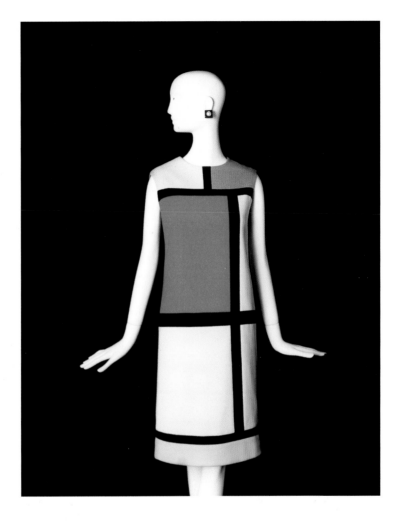

Biennale of 1952, where the Dutch Pavilion hosted an exhibition dedicated to De Stijl. Today his studies and paintings have an almost ubiquitous presence in the collections of major museums around the globe, no doubt partially due to his prolific nature. Yet his international impact is such that his work has found acceptance in the world of architecture and design (with which it clearly has much in common) and in the popular imagination, which had previously seemed unable to come to terms with abstract art, even in its most accessible form.

Over time, Mondrian's innately elegant three-color compositions, whose resolute yet light structure encourages interpretations on many levels, have found practical applications that the Dutch artist could never have imagined, ranging from fashion to food styling (see, for example, Barilla's artful pasta ads or the inspired desserts of California chef Caitlin Freeman). As Mondrian himself stated at the beginning of his journey as an artist, one must "strive to express in the work of art what is essential of man and nature; that is, what is universal." The perfection of his shapes and the harmony of his colors evoke subjective reactions in spite of their presumed neutrality. Such responses demonstrate just how well Mondrian's work hits the mark in tracing the delicate relationship between individuality and collectivity even when it avoids any reference to reality.

NIGHTHAWKS
Edward Hopper

1942 Oil on canvas, 84 × 152 cm
— The Art Institute of Chicago, Friends of American Art Collection , 1942.51

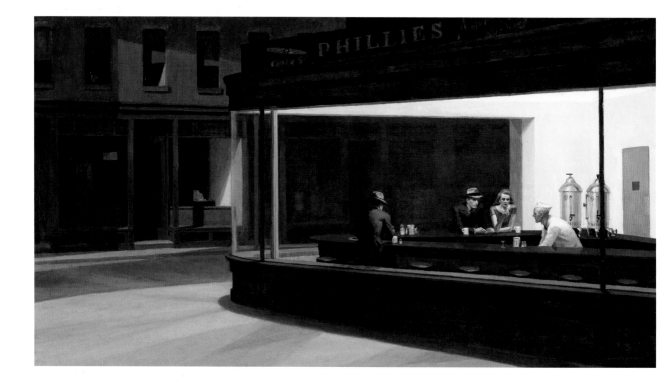

I never tried to do the American Scene as Benton and Curry and the midwestern painters did. I think the American Scene painters caricatured America. I always wanted to do myself.

..................................

Edward Hopper

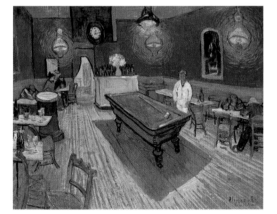

Vincent van Gogh
The Night Café, 1888
Oil on canvas, 72 × 92 cm
Yale University Art Gallery, New Haven,
Connecticut, bequest of Stephen Carlton Clark,
B.A. 1903

Although it wasn't how he thought of himself, Edward Hopper (1882–1967) has become the quintessential painter of modern America. He depicted the solitude of the nation and the desolation of its urban landscapes in an extraordinarily accessible style, where the absence of narrative specificity transforms the subjects into universal symbols of existential crisis.

Nighthawks, for instance, is a scene that unfolds inside a New York diner, possibly at the intersection of Seventh Avenue, Eleventh Street, and Greenwich Avenue. The title, an oblique reference to the nocturnal creatures that populate large metropolitan areas, along with the meager information about the characters and setting, reinforces the sensation of a painting meant to evoke an ordinary moment in the life of any American city. The key to the immense popularity of *Nighthawks*, which quickly turned into Hopper's best-known and often-cited work, resides precisely in its evasion of any explicit reference or explanation, so that the nighttime drama may be completed by anyone who observes it. The pictorial surface becomes a screen for projection; it lends itself to the most general of suggestions, creating a feeling of déjà vu, as if the viewer has experienced something similar in a different time or place.

The deliberately diagonal perspective, with two rows of figures overlapping, encourages us to identify with the seated man who is depicted from the back, facing a couple on the other side of the counter (Hopper and his wife). The patrons thus help to characterize the joint, assigning it a dual nature as both shelter and temporary station for solitary spirits and lovers on the run, on the verge of beginning or concluding their day.

More than a realist painter, Hopper is a re-creator of psychological atmosphere, and in this sense he was right to feel that he was an outsider to the contemporary American scene. He never painted from life but rather staged dramas with figures that look like actors playing their parts, not making eye contact with the camera and blissfully unaware of the director who observes them. Indeed, one of the reasons *Nighthawks* is so famous is its "cinematographic angle," though it is impossible to establish if cinema was inspired by Hopper or vice versa.

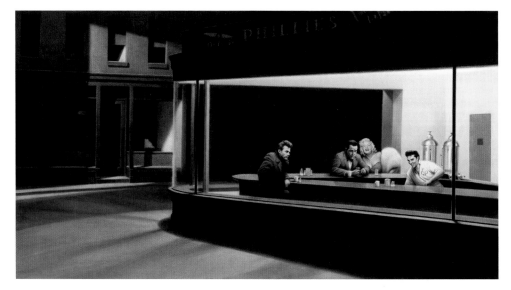

Gottfried Helnwein
*Boulevard of
Broken Dreams*, 1984
Watercolor and acrylic
on paper, 150 × 210 cm
Private collection

Cover of the Tom Waits
album *Nighthawks at
the Diner*, 1975

The fact that Hollywood and Hopper both emerged in the 1920s in a similar cultural and social climate legitimizes the idea that his paintings made an impression on the collective imagery precisely because they are cinematographic, with cinema confirming them as such and at the same time adopting them for its own language. In short, the attraction was mutual.

What is clear is that cinema, in retrospect, has only increased Hopper's celebrity. Many directors have cited or even reconstructed *Nighthawks*, including Herbert Ross in the musical *Pennies from Heaven* (1981), James Foley in *Glengarry Glen Ross* (1992), and Wim Wenders in *The End of Violence* (1997)—not to mention the artist's greatest admirer, Alfred Hitchcock, who evoked the Hopper canvases *Night Windows* (1928) and *House by the Railroad* (1925) in his masterpieces *Rear Window* (1954) and *Psycho* (1960). Wenders in particular identified among the artist's strengths the ease with which one intuits "where the camera is" in his paintings. It is worth noting that Hopper was a great fan of film noir and had, at the beginning of his career, worked as an illustrator of theatrical posters and book covers.

The extent to which artists study the work of other artists should not be underestimated, though. Hopper's particular inspiration for *Nighthawks* may have been Vincent van Gogh's *Night Café* (1888). The American

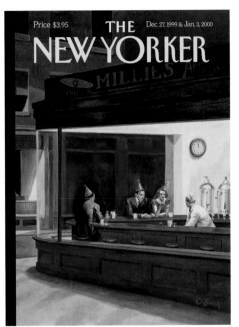

Cover of Philippe Besson's novel *L'arrière saison* (Éditions Julliard, 2002), whose characters are inspired by the figures in Hopper's painting

Owen Smith's New Year's Eve take on Hopper's *Nighthawks* for the December 27, 1999–January 3, 2000 issue of *The New Yorker*.
Smith / *The New Yorker*
© Condé Nast

artist knew the painting well; it had been purchased by one of his greatest supporters, Stephen Clark, when the Soviet government, which had nationalized Ivan Morozov's private collection, secretly put it up for sale in 1933. *The Night Café* was exhibited at the Museum of Modern Art, New York, from November 19, 1934, through January 20, 1935, a period during which Hopper's own work was frequently shown. The catalogue for a subsequent Van Gogh exhibition, in 1935, included the artist's own description of the painting: "In my picture of the *Night Café* I have tried to express the idea that the café is a place where one can ruin oneself, go mad or commit a crime. So I have tried to express, as it were, the powers of darkness in a low public house . . . an atmosphere like a devil's furnace." He could as well have been describing the diner in *Nighthawks*.

Van Gogh connection aside, it is likely that Hopper would have come up with a representation of a diner at some point during the course of his exploration of American society. The ordinariness of a subject is key in establishing its subsequent influence and recurrence, and the legion of American artists who have quoted Hopper—from George Segal to Richard Estes to Stephen Shore—would seem to confirm this. Shore especially, along with Joel Sternfeld and William Eggleston, belongs to a group of "vernacular" photographers who, in the late 1960s and early 1970s, made work in color that continued the investigations initiated decades earlier by pioneers such as Harry Callahan and Walker Evans—

a fact that demonstrates how Hopper's vision, especially his study of light and the distinctive perspective of his compositions, has also influenced photography.

In Europe, *Nighthawks* quickly earned icon status and has often been used on book covers as a symbol of a decadent "stars and stripes" mythography. It has likewise been associated with those Hollywood film stars of the 1950s who met a tragic end. The Austrian artist Gottfried Helnwein, for example, created a renowned reinterpretation of the painting that replaces Hopper's figures with Elvis Presley, James Dean, Humphrey Bogart, and Marilyn Monroe. Helnwein produced the image in 1984, in the wake of a 1950s revival fueled by films and television shows such as *American Graffiti*, *Happy Days*, and *Grease* and culminating with the election of Ronald Reagan—a time when America, in the midst of a post-Vietnam, post-Watergate identity crisis, was looking back on those years as a golden age of healthy values, deliberately ignoring the dark side of the Cold War, McCarthyism, and the birth of the CIA, and sweeping up Hopper's image, too, in this wave of nostalgia.

GOLD MARILYN MONROE
Andy Warhol

1962 Silkscreen ink on synthetic polymer paint on canvas, 211 × 145 cm
— The Museum of Modern Art, New York, gift of Philip Johnson

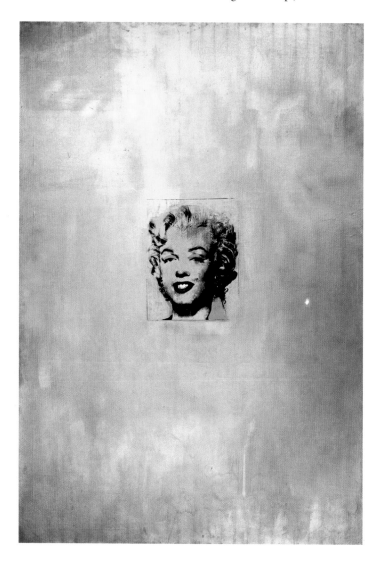

> **The icon is meant to raise consciousness to the spiritual realm, to reveal mysterious and supernatural visions.**
>
>
>
> Pavel Florensky

Andy Warhol (1928–1987) was, in addition to being tirelessly gregarious ("I have a social disease. I'd go to the opening of anything, including a toilet seat"), a devout Christian who attended New York's Church of Saint Vincent Ferrer on Lexington Avenue every Sunday. He inherited his faith from his mother, a follower of the Uniate church, which is closer to Greek Orthodoxy than Roman Catholicism in its veneration of icons and emphasis on a solemn ritualism that has remained unchanged over centuries. As Warhol's friend Daniela Morera has written, "In some ways Warhol's Pop icons (the Marilyn Monroe series in particular) are actually post-Byzantine icons, which they recall in the dimensions, their use of yellow and gold and the way the central image is made to stand out by the uniformity of the background color. The icons of Russo-Byzantine tradition are standardized too. They are hypnotic forms, beads of a devotional rosary, in which each image alludes to the others in a continuous production line of meaning. The flat surface of the icon is the threshold of passage from the visible to the invisible, from the plane of human reality to a more transcendent one."

Hence Warhol was a believer, and as such he went on to create what is possibly the icon of all icons: *Gold Marilyn Monroe*, a secular work of art that more than any other encompasses the concept of the sacred image. Characterized by a gold background like a Byzantine figure, Warhol's Marilyn is the representation of a contemporary divinity, unattainable and within reach of everyone at the same time, just as the image of the Virgin Mary was for centuries.

Warhol's advantage was his deep understanding of how repetition is the fundamental ingredient of ritual (consider, for instance, benedictions, processions, prayers, the rosary, mantras) and its relation to the sacred—and thus to the imagination of a contemporary society devoted to the religion of mass consumption. It was precisely the practice of seriality that brought Warhol widespread attention and turned him into the priest of this cult. He divined that through the redeeming power of art, one could seize an insignificant object, like a box of detergent from a supermarket shelf, and

Virgin of Tikhvin, late fifteenth century
Tempera on limewood, 32 × 27 cm
Zagorsk State Historical and Art
Museum, Sergiev-Posad

take it to a transcendent level.

The project through which Warhol honed his idea is the one he created around the holy figure of Marilyn Monroe. He began the first portrait after the star's suicide on August 5, 1962. During the 1960s Warhol completed three separate series of Marilyns, all based on a black-and-white photo, the translation of which into silkscreen is nothing but a technical and concrete consequence of one of the cardinal tenets of consumerism. As Warhol himself put it, "You can be watching TV and see Coca-Cola, and you know that the President drinks Coke, Liz Taylor drinks Coke, and just think, you can drink Coke, too. A Coke is a Coke and no amount of money can get you a better Coke than the one the bum on the corner is drinking."

Warhol's silkscreens simultaneously created and exploited icons of capitalist culture such as the dollar sign and soup can as well as the faces of Mao Tse-tung and Marilyn Monroe, embodying the collective myth of a generation and its competing allure—on the one hand engagement and on the other lightness, on a scale of values that is ultimately leveled by the culture of mass consumption.

Little by little, Warhol's name was transformed into a trademark capable of transfiguring a painting into an object of worship, an effect operating according to the same irrational mechanism that governs the sacred. In a way, his silkscreens are the equivalent of a cheap printed holy image that can be purchased at a souvenir stand but has the same miraculous power as the original saint. Whoever bought a Warhol silkscreen could consequently possess the same status symbol owned by the rich and famous. And whoever substituted their own faces for that of Marilyn Monroe—as did the new stars of rock and fashion, including Madonna and Kate Moss—would consequently enjoy the popularity of the true icon, the miraculous Marilyn.

A "gold Marilyn" of coins for a financial ad by MUW Saatchi & Saatchi, Bratislava, Slovakia, 2008

Homage to Andy Warhol:
Barbie Marilyn Monroe by
Jocelyne Grivaud, made on
the occasion of Barbie's
fiftieth anniversary, 2009

Mr. Brainwash
Reborn, 2011
Color silkscreen, 56 × 56 cm
Courtesy of Mr. Brainwash

The visibility of his activities at the Factory, from films to *Interview* magazine, as well as the creation of Andy Warhol Enterprises, turned Warhol into an extremely recognizable brand as well as the first modern artistic corporation. Big companies initially sued him because he used their logos, but eventually they paid him to do it. Warhol transformed Mercedes-Benz cars, Perrier water, Levi's 501 jeans, Muratti Ambassador cigarettes, and other goods into works of art, creating a short circuit between the products and his own fame. One might say that when a Warhol painting goes to auction, it is more about the value of a dual brand than about a work of art.

He was also aware that the media had changed the world and artists had to adjust accordingly: "Nowadays you can write books, go on TV, grant interviews: you are a big celebrity, and no one despises you even if you are a con artist. You are always a star. This happens because people need stars more than anything else." But there is a risk, as the critic Michael Fried pointed out. "An art like Warhol's is necessarily parasitic upon the myths of its time, and indirectly therefore upon the machinery of fame and publicity that market these myths," he wrote. "And it is not at all unlikely that the myths that move us will be unintelligible (or at best starkly dated) to generations that follow."

SON OF MAN
René Magritte

1964 Oil on canvas, 116 × 89 cm — Private collection

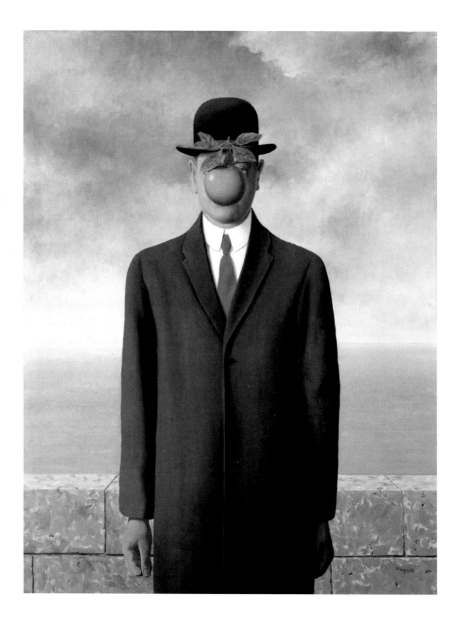

My painting is visible images which conceal nothing; they evoke mystery and, indeed, when one sees one of my pictures, one asks oneself this simple question, "What does it mean?" It does not mean anything, because mystery means nothing either, it is unknowable.

René Magritte

Borsalino poster by Armando Testa, 1954

Those familiar with the work of René Magritte (1898–1967) will surely be a little perplexed at the selection of *Son of Man* as the most iconic work of his artistic production. What of the debate on the disconnect between image and object in *The Treachery of Images (This Is Not a Pipe)* (1929)? Or the superimposition of reality and fiction in *The Human Condition* (1933)? Or even the raining men with bowler hats and umbrellas in *Golconda* (1953)? Magritte was one of the greatest beneficiaries of the Surrealist revival of the postwar period, yet he did not achieve cult status through the creation of a single masterpiece; he is best known, instead, for the persistent repetition of some of the distinctive elements that populate his universe. It is the same process that distinguished the work of artists such as Piet Mondrian, Roy Lichtenstein, or Keith Haring, where the meaning of the individual painting often comes across as secondary to the artist's visual vocabulary.

Of all of Magritte's recurring themes that one might choose to illustrate this concept, two in particular stand out: the faceless man in the black suit and hat and the green apple. The man, who made his first appearance in 1926 in *The Musings of the Solitary Walker*, was the artist's favorite form of self-portraiture, though the generic costume, combined with the absence of facial features, contributed to the more sociologically appealing idea of the figure as a representation of the everyman, or to his more politicized identification as a generic businessman—an anonymous cog in a diabolical machine. The second image, the green apple, opens up a range of historical references ranging from the story of Paris in Greek mythology to Adam and Eve and even to Isaac Newton, introducing in works such as *The Hesitation Waltz* (1950) and especially *The Listening Room* (1952) the kind of food-related dimensional deception that Claes Oldenburg would translate into sculpture some years later.

Magritte could count among his admirers major collectors as well as intellectuals of the caliber of André Breton and Tristan Tzara, yet still he struggled to find success. Caught between the advent of abstraction on the one hand and the proliferation of photography on

Poltrona Frau ad
by Armando Testa, 2004.
The tagline reads, "Knowing how
to live is an art form."

SeonHyoung Kim
Son of Mac, 2009
Decal sticker
Produced by
Art Wall Project

the other, he responded with an approach to painting that relied on realism as the foundation to interpret and distort the world. *Son of Man*—painted at the same time as its female counterpart, *The Great War on Facades*, and in many further variations, including *The Man in the Bowler Hat*, *The Great War*, and *The Taste of the Invisible*—was first exhibited by the influential dealer Alexander Iolas in his Paris and New York galleries in November 1964 and January 1965, respectively, before being sold to a private collector. It was also included in a December 1965 retrospective of Magritte's work at the Museum of Modern Art, New York, which received an enthusiastic critical reception. John Canaday, writing in the *New York Times*, found the recent works to be the most interesting, with the exhibition marking a turning point in the artist's career.

Magritte's curious balance between absolute normality and unexpected eccentricity could not help but appeal to the public in the second half of the 1960s—a revolutionary period during which many were questioning the perception and definition of reality. Robert Fraser, the London art dealer known principally for having been immortalized by Richard Hamilton in handcuffs in *Swingeing London 67 (f)*, introduced Magritte's work to Paul McCartney. The Beatle was so struck by it that he became an avid art collector and, perhaps inspired by the image's melding of fruit and commerce, decided to use the green apple as the logo for Apple Corps, the company founded by the Beatles in 1968. The following year Jeff Beck borrowed Magritte's apple for the cover of his second album, *Beck-Ola*. And in 1970 both the apple and the suited figure made an enigmatic appearance at the end of the video for "Astral Traveller" by the British rock band Yes. In 1976, in Cupertino, California, Steve Jobs, Steve Wozniak, and Ronald Wayne devised a rainbow-striped variation with a bite taken out of the side as the logo for Apple Inc.—a design that led to a lawsuit from the Beatles that would

Cover of H. G. Wells's
The Invisible Man, 2010

Magimix's "Only the
exceptional last" ad by
Y&R Israel, 2011

not be definitively settled for thirty years.

In the advertising field, at least two campaigns have made use of the iconography in *Son of Man*. In 2004 Armando Testa extrapolated some Magrittian patterns, including the sky and the hat, to promote an armchair by Poltrona Frau, and in 2011 the agency Y&R Israel recast the painting using various vegetables to market the Magimix food processor, creating an image that might best be described as Magritte filtered through the sensibility of Giuseppe Arcimboldi.

The ongoing tributes to *Son of Man* bestowed by popular culture over the years via cinema (*The Thomas Crown Affair*, *The Magic Mountain*), literature (*The Invisible Man*), television (*The Simpsons*), and music (Michael Jackson and Janet Jackson, Paul Simon) have continued to keep alive the painting's popularity. Such appropriations, however, are more conspicuous for quotation rather than reinterpretation. Endowed with a clear and direct style, and drawing on a repertory of objects and settings that are immediately recognizable, Magritte's work proffers an opportunity to explore the paths of the surreal without ever completely losing one's way. It is an accessible entry point to conceptual art to those who are reluctant to sever ties with most traditional forms of expression.

Essential Reading

Adler, Kathleen. *Manet*. London: Phaidon, 1986.

Alley, Ronald. *Catalogue of the Tate Gallery's Collection of Modern Art other than Works by British Artists*. London: Tate Gallery and Sotheby Parke-Bernet, 1981.

Apollonio, Umbro, ed. *Futurist Manifestos*. Documents of 20th Century Art. New York: Viking, 1973.

Baedeker, Karl. *Paris and Its Environs*. Leipzig, Germany, 1913.

Baxandall, Michael. *Patterns of Intention: On the Historical Explanation of Pictures*. New Haven, CT: Yale University Press, 1985.

Berenson, Bernard. *The Study and Criticism of Italian Art*. London: George Bell and Sons, 1916.

Bischoff, Ulrich, and Anne Lemonnier. *Edvard Munch*. Cologne: Taschen, 1990.

Blunt, Anthony. *Picasso's Guernica*. London: Oxford University Press, 1985.

Buranelli, Francesco, et al. *Laocoonte 2006*. Rome: Musei Vaticani, 2006.

Butler, Ruth. *Rodin: The Shape of Genius*. New Haven, CT: Yale University Press, 1993.

Calza, Gian Carlo. *Hokusai*. London: Phaidon, 2003.

Centanni, Monica. *Classico manifesto: Temi della tradizione classica nella pubblicità italiana*. Rome: Fondazione Valore Italia, 2008.

Chastel, André. *Botticelli*. Greenwich, CT: New York Graphic Society, 1958.

Clair, Jean, David Sylvester, and Louise Scutenaire. *Rétrospective Magritte*. Brussels: Palais de Beaux-Arts; Paris: Centre Georges Pompidou, 1978–79.

Comini, Alessandra. *Gustav Klimt*. London: Thames and Hudson, 1975.

Corn, Wanda M. *Grant Wood: The Regionalist Vision*. New Haven, CT: Yale University Press, 1983.

Debray, Régis. *Vie et mort de l'image*. Paris: Gallimard, 1992.

Duncan, David Douglas. *Sunflowers for Van Gogh*. New York: Rizzoli, 1986.

Feigenbaum, Gail, and Sybille Ebert-Schifferer. *Sacred Possessions: Collecting Italian Religious Art*. Los Angeles: Getty Research Institute, 2011.

Fischel, Oskar. *Raphael*. London: Spring Books, 1964.

Flam, Jack. *Matisse and Picasso: The Story of Their Rivalry and Friendship*. Cambridge, MA: Westview Press, 2003.

Focillon, Henri. *The Life of Forms in Art*. New York: Zone Books, 1989.

Freedberg, David. *The Power of Images: Studies in the History and Theory of Response*. Chicago: University of Chicago Press, 1989.

Friedlander, Walter. *David to Delacroix*. Cambridge, MA: Harvard University, 1974.

Furtwangler, Adolf. *Masterpieces of Greek Sculpture*. London: Sellers, 1895.

Gombrich, Ernst Hans. *Studies in the Art of the Renaissance*. Oxford: Phaidon, 1986.

Grabar, André. *The Beginnings of Christian Art, 200–395*. London: Thames and Hudson, 1967.

Haskell, Francis, and Nicholas Penny. *Taste and the Antique: The Lure of Classical Sculpture 1500–1900*. New Haven, CT: Yale University Press, 1981.

Hatfield, Rab. *Trust in God: The Sources of Michelangelo's Frescoes on the Sistine Ceiling*. Florence: Syracuse University, 1991.

Heller, Reinhold. *Edvard Munch: The Scream*. London: Penguin, 1973.

Hughes, Robert. *The Shock of the New: Art and the Century of Change*. New York: Thames and Hudson, 1991.

Hüttel, Richard. *Spiegelungen einer Ruine: Loenardos Abendmahl im 19. und 20 Jahrhundert*. Marburg, Germany: Jonas, 1994.

Huyghe, René. *Delacroix*. New York: Abrams, 1963.

Jassen, Hans, Franz W. Kaiser, and Matthias Mühling. *Mondrian De Stijl*. Ostfildern, Germany: Hatje Cantz, 2011.

Kemp, Martin. *Leonardo da Vinci: The Marvellous Works of Nature and Man*. Oxford: Oxford University Press, 2007.

Kubler, George. *The Shape of Time*. New Haven, CT: Yale University Press, 1972.

Levin, Gail. *The Complete Oil Paintings of Edward Hopper*. New York: Whitney Museum of American Art, 2001.

Mandel, Gabriele, ed. *L'opera completa del Botticelli*. Milan: Rizzoli, 1967.

Marani, Pietro, ed. *Il Genio e le Passioni: Leonardo e il Cenacolo; Precedenti, innovazioni, riflessi di un capolavoro*. Milan: Skira, 2001.

Martin, Russell. *Picasso's War: The Extraordinary Story of an Artist, an Atrocity, and a Painting that Changed the World*. New York: Scribner, 2003.

Mondrian, Piet, Harry Holtzman, and Martin S. James. *The New Art, the New Life: The Collected Writings of Piet Mondrian*. London: Thames and Hudson, 1987.

Murray, Alexander Stuart. *A History of Greek Sculpture*. Vol. 1, *From the Earliest Time down to the Age of Pheidias*. Boston: Adamant Media Corporation, 2001.

Parinaud, André. *The Unspeakable Confessions of Salvador Dalí*. New York: William Morrow, 1976.

Pater, Walter. *Greek Studies: A Series of Essays*. London: Macmillan and Co., 1895.

Pérez Sánchez, Alfonso E. *Goya*. New York: Holt, 1990.

Phillips, Samuel. *Guide to the Crystal Palace*. London: Euston Grove, 2008.

Ritzer, George. *Enchanting a Disenchanted World: Continuity and Change in the Cathedrals of Consumption*. London: Sage, 2010.

Robertson, Martin. *A History of Greek Art*. London: Cambridge University Press, 1975.

Rossi Bortolatto, Luigina. *L'opera completa di Delacroix*. Milan: Rizzoli, 1972.

Sagner-Dutching, Karin. *Claude Monet 1840–1926*. Cologne: Taschen, 1994.

Sassoon, Donald. *Mona Lisa. The History of the World's Most Famous Painting*. London: HarperCollins, 2001.

Schellmann, Jörg. *Andy Warhol: Art from Art*. Ostfildern, Germany: Hatje Cantz, 1994.

Settis, Salvatore. *Laocoonte: Fama e stile*. Rome: Donzelli, 1999.

Tøjner, Poul Erik. *Munch in His Own Words*. New York: Prestel, 2003.

Tolnay, Charles de. *Michelangelo: The Sistine Ceiling*. Princeton, NJ: Princeton University Press, 1945.

Van Gogh, Vincent. *The Letters of Vincent van Gogh*. London: Penguin, 1997.

Vasari, Giorgio. *The Lives of the Artists*. Translated with an introduction and notes by Julia Conaway Bondanella and Peter Bondanella. Oxford: Oxford University Press, 1991.

Villata, Edoardo, ed. *Leonardo da Vinci: I documenti e le testimonianze contemporanee*. Milan: Castello Sforzesco, 1999.

Warburg, Aby M., Uwe Fleckner, and Isabelle Woldt. *Bilderreihen und Ausstellungen*. Berlin: Akademie, 2012.

Wittgens, Fernanda. *Leonardo: Saggi e ricerche*. Rome: Istituto Poligrafico dello Stato, 1954.

Zola, Émile, and Nathalia Brodskaïa. *Édouard Manet*. New York: Parkstone, 2011.

Copyright and Photo Credits

© Lazy Dog Press, 2014
Texts © Francesca Bonazzoli
and Michele Robecchi, 2014
Preface © Maurizio Cattelan, 2014
English translation © Prestel Verlag,
Munich • London • New York, 2014

Published by Prestel, a member of
Verlagsgruppe Random House GmbH

Prestel Verlag
Neumarkter Strasse 28
81673 Munich
Tel.: +49 89 41 36 0
Fax: +49 89 41 36 23 35

Prestel Publishing Ltd.
14–17 Wells Street
London W1T 3PD
Tel.: +44 (0)20 7323 5004
Fax: +44 (0)20 7323 0271

Prestel Publishing
900 Broadway, Suite 603
New York, NY 10003
Tel.: +1 212 995 2720
Fax: +1 212 995 2733
E-mail: sales@prestel-usa.com

www.prestel.com

Library of Congress Cataloging-in-Publication Data

Bonazzoli, Francesca.
 [Io sono un mito. English]
 Mona Lisa to Marge: how the world's greatest artworks
entered popular culture / Francesca Bonazzoli, Michele
Robecchi ; preface by Maurizio Cattelan.
 pages cm
 ISBN 978-3-7913-4877-3
1. Art and popular culture. 2. Masterpiece, artistic. I. Title.
N72.S65.B6613 2014
700.1'04—dc23
 2013016788

Concept by
Riccardo Bozzi

Edited and produced by
Debbie Bibo

Editorial direction by
Karen A. Levine

Design by
Pitis

Cover art by
Nick Walker
Mona Simpson, 2006 (original
background color is pink as seen
in the reproduction on p. 49)

Cover design and layout by
Bunker

Picture research by
Debbie Bibo
Marie-Laure Jouve

Translated from the Italian by
Marguerite Shore

Proofread by
Samantha Waller

Separations by
UnoUndici, Verona

Printed in Italy by
Grafiche Flaminia Srl, Trevi